ROBERT GENN: *In Praise of Painting*

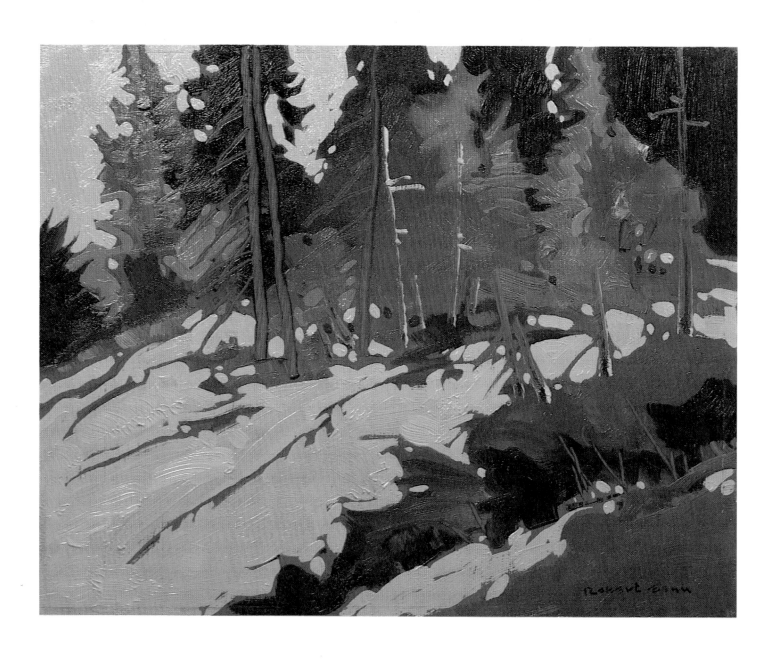

1 WESTERN SLOPE 1981
oil on panel, 8 × 10 inches

ROBERT GENN

In Praise of Painting

by Robert Genn

Introduction by Karen Keenlyside Mills

MERRITT PUBLISHING COMPANY LIMITED

Toronto / Vancouver

© Copyright 1981 Robert Genn

Published by Merritt Publishing Company Limited
Toronto / Vancouver

Distributed in Canada by John Wiley and Sons Canada Limited

Canadian Cataloguing in Publication Data

Genn, Robert, 1936 —
Robert Genn: in praise of painting

ISBN 0-920886-17-5 (Trade Ed.)

1. Genn, Robert, 1936 – 2. Painters – Canada – Biography.
I. Title.

ND249.G46A2 1981 759.11 C81-094808-7

TABLE OF CONTENTS

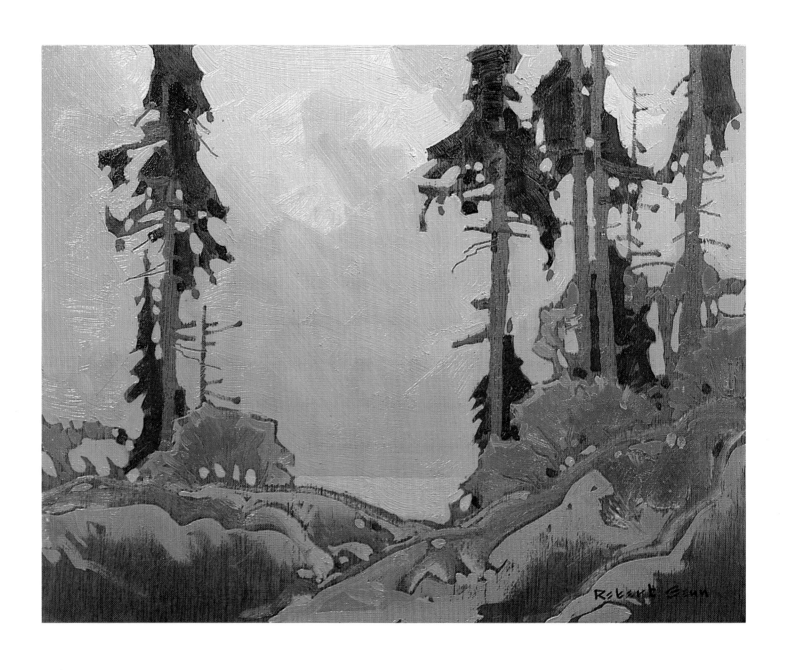

2 GULF PATTERN 1980
oil on panel, 8 × 10 inches

FOREWORD

Painting is a life-long commitment and a growing love affair. It is also a frustrating game in which the opponent is one's self. Full of triumphs, it brings an elation like no other endeavour I know of. These little triumphs can occur late at night, early in the morning, or fifty times during the day. Then there are the months when there are no triumphs at all.

I feel a profound sense of good luck to be living my life as a painter. I am grateful to my parents who provided encouragement without overwhelming me, and to my close friends who have blessed me with their objectivity and sense of humour. My wife Carol has paid me the greatest compliment of all by believing that we could do whatever we wanted and be okay. We have also found time to create a lovely family together. Carol's ability to orchestrate our happy social life to fit into and around my work habits has been no small accomplishment. I dedicate this book to her, and to our children David, James and Sarah. I hope they can grow up in a peaceful world and find work that they can learn to love.

The text of *In Praise of Painting* has been extracted from tape recordings made in Hawaii during two weeks in January 1981. The format is largely chronological, bringing the artist to the advanced age of forty-four, and leaving him there, his work unfinished and unperfected.

The paintings and drawings included in this book were chosen from private collections, and I would like to thank all of the collectors who have been kind enough to allow my

work to be photographed. Some memorable works proved impossible to find, and a few decidedly poorer ones have been included in order to give the reader an idea of the stages of development.

Many people provided help and encouragement in the preparation of the manuscript. I would like to thank Bill Atkinson of Merritt Publishing Company Limited who insisted that I get busy and give him a book to publish. He is the kind of spark plug that makes things happen in the art world. Special thanks go to Mary Gillis, Peter Gellatly, Andrée Fleming, Jack Hambleton, my assistant Ulrike McLelan, and Helen Wooldridge and Rachel Rafelman of Merritt who have succeeded in putting the whole project together.

<div style="text-align: center;">

R. G.

British Columbia 1981

</div>

INTRODUCTION

Many years ago in a gallery in Victoria, I came across a small painting by an artist unknown to me at the time. I fell in love with it, and it became the first of many works by Robert Genn that I have since acquired. Not long after, I had my first meeting with Robert, an event that resulted in my employment with his dealer and to my own career as an art dealer. It was also the beginning of a long and eventful friendship.

An unpredictable man—from raffling off the chassis of a car at his fortieth birthday party to shaving off his beard for charity—Robert's enthusiasm and curiosity about life are transmitted through his personality and his art. His dedication and perseverance have sustained him through the fluctuations of the art market, and he has passed the most crucial test of the artist, the test of time.

Robert Genn occupies a unique position in Canadian art. Assimilating a wide range of influences, from Japanese woodcuts to the Group of Seven, he has kept alive the tradition of Canadian landscape schools in a style that is his alone. Genn bridges the gap between popularity and the elements of good art and, as a result, has earned a large and faithful following without compromising his standards.

Although Robert has inspired many imitators, his work contains a special quality that comes out of the creator and cannot be duplicated. His idealistic representations of nature are extensions of Genn the optimist; the careful composition of each canvas emerges from Genn the perfectionist.

In order to understand any art form it is necessary to know something of its creator. This book, I hope, will give the reader insight into Genn as a man and an artist. Robert has always been generous and eager to share his experience and knowledge; this book is a testament to that generosity. I hope it will inspire collectors and artists alike, for the language of art speaks not only to the eye but also to the spirit.

KAREN KEENLYSIDE MILLS
Ancaster, Ontario 1981

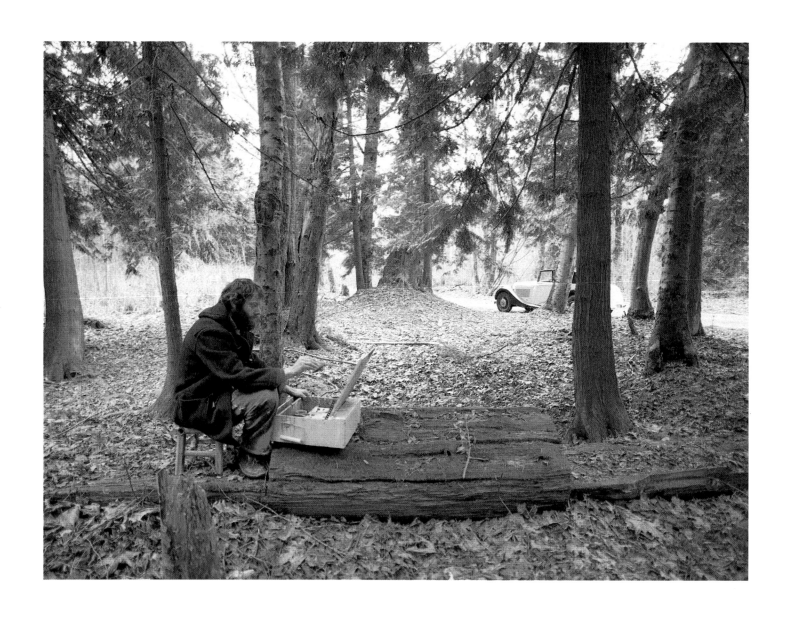

3 *The artist painting in the woods*
photo: Bill Staley

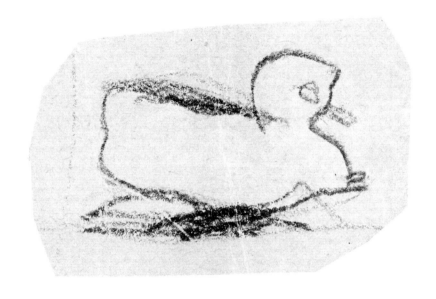

1 *Duck drawn by the author at age three years, two months. This drawing is in the permanent collection of the artist's mother.*

THE EARLY YEARS

When I was three I did a drawing of a duck. My parents thought it was wonderful. No one will ever know for sure whether that duck was really good, or my parents just believed it was, but I have been a painter ever since. Drawing that duck taught me that the work of an artist is really a form of play, a belief that remains unshaken to this day.

I was born in Victoria, British Columbia, on May 15, 1936 to Hugh and Florence Genn. The earliest home I remember was a small bungalow at Cordova Bay near Victoria. My father used to paint in his spare time. He used the rough side of Masonite and the inside of scallop shells, or he would do little scenes of Mount Baker on small panels. He once painted a large portrait of Winston Churchill and photographed it leaning against his 1940 Hillman Minx. Sometimes my uncle's boat, the Miss Reveller, a twenty-six foot, plum-bow open launch was anchored below our home, and we would cruise out over the wonderful water and, with a gang of Cowichan spoons, take grilse from Cordova Bay. One of my earliest visual recollections is of tiny, heroic tugs with two and three barges in tow steaming towards Vancouver past our home.

Every Saturday afternoon my father would bring home large quantities of off-cut paper and cardboard from the factory he worked in. This meant that I had the tremendous advantage of always having material to draw or paint on. I would quickly use up whatever was brought to me and spend the rest of the week eagerly awaiting the next shipment. Having

an abundance of art supplies has always made me happy. To this day I will go out and buy canvases or panels when I'm feeling low.

When I was four years old and out for a drive with my grandfather, I saw Emily Carr. It was only a glimpse but I remember her well—a short, stout woman seated on a folding stool painting a picture. My grandfather told me her name and said that a lot of people thought she was crazy. She died five years later and although I never saw her again, I came to know and admire her through her work. Emily Carr painted her greatest paintings when she was already well past middle age; a note of hope for older painters. She has had a major influence on my work. I am glad I caught sight of her once.

1942 was distinguished by two events: my family moved to Cedar Hill Crossroad, closer in to the city of Victoria; and on October 30th my brother Denis was born. Denis proved to possess a natural talent for art criticism, frequently amending my drawings with his crayons, breathing heavily on my stamp collection and rearranging my priceless collection of rotten wood. Denis grew up to become an accountant.

My father started his own business doing sign work, silk-screen process printing, building displays and parade floats. A young employee of his, Mort Graham, gave me my first art lesson. He asked me to do a drawing in India ink of a bottle of India ink, and when I had finished, scrutinized my drawing carefully. 'You have done just what I thought you would do,' he remarked. 'Rendered a tolerable likeness of the bottle while leaving out its most essential quality.' The blackness and inkiness of the bottle was absent from my drawing. It was my first lesson in finding the essence of things.

Art was always my best subject in school. In grade five, a new system was inaugurated by the Victoria School Board which permitted the better art students to go to what was then called the Saturday Morning Art Classes at Central Junior

High School. Budding artists from around Victoria got together on Saturday mornings. The instructor was a young enthusiast by the name of John Lidstone who had been exposed to a contemporary art training in New York. He introduced us to a wide range of techniques. John Lidstone often took some of his students in his tiny car on field trips in the country. We visited the bold headlands and rocky beaches in the Sooke area and sketched lady slippers at Goldstream.

I soon began to draw enthusiastically and take private lessons in watercolour from Will Menelaws, an accomplished figurative artist who exhibited locally. I would sit in Menelaws's icy back studio patiently reducing all my subjects to light, halftone and dark, as instructed. 'Where you see colour, emphasize,' he stressed.

In 1949 the family moved to Persimmon Drive, a sunny hilltop with a commanding view of Mount Douglas. I was kept busy doing drawings for the Mount Douglas High School Annual and the school newspaper, and working in my father's sign shop pulling the squeegee or racking bus cards and real estate signs.

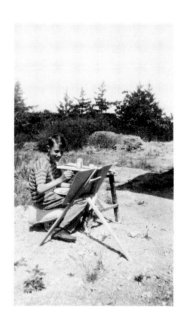

A keen and active birdwatcher in those days, I had logged most of the birds on the Provincial Museum List by 1951. I also collected butterflies and various kinds of mushrooms which I would arrange around the dining room and paint.

My favourite place was Lost Lake, a small waterbody shaped like an infinity sign. I came to think of this place as my own and used to sit in a thicket by the water's edge, drawing, watching birds through my binoculars and writing unmemorable, derivative poems of a semi-romantic nature.

I had found a soulmate in my friend Fen Lansdowne, a budding bird artist who joined me in my quest for ornithological knowledge. He and I used to trip off together to Mechosin, Deep Cove, Mount Douglas Park or Lost Lake to collect

2 *The artist at age twelve*

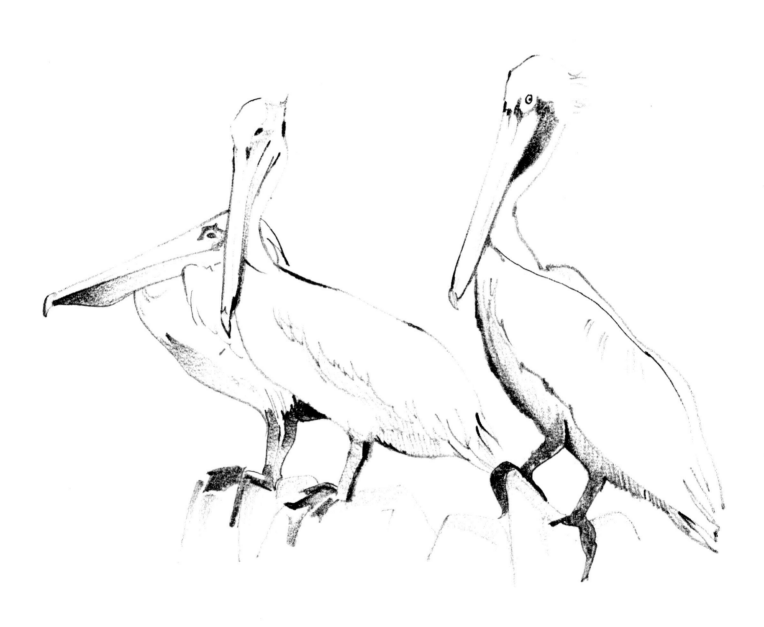

specimens for drawing. Fen's mother Edith Lansdowne was also an avid birdwatcher and willingly took us everywhere in their 1948 Ford. Those were happy times for me. I wrote a short essay in grade ten entitled 'Bobbie's Hobbies' in which I described the pleasures of taking in the wonders of the earth. It ended grandly with a quote from Robert Louis Stevenson: 'The world is so full of a number of things that I'm sure we should all be as happy as kings.'

My first work in oil, showing a collection of boats at wharfside, was produced while sitting in the back seat of Lansdowne's car by the estuary at Courtenay in the northern part of Vancouver Island. It was a modest work, significant only because of one feature–the sky shown through the masts, an image that has become characteristic of my work. At the time, oil paint seemed stiff and uncompromising in comparison to the watercolours that I was accustomed to. But it also had a permanent, monumental quality that water-colours lacked and that I responded to. It was the difficult beginning of a long love affair.

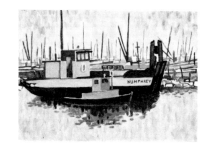

In 1952, after working diligently for my father for several months, I acquired my first car–a 1929 Hupmobile coupe with a rumble seat. It was truly a great moment in my life! The car, which was maroon when I got it, soon acquired a lustrous coat of bright red paint and beautiful black fenders. I could now taste true freedom.

Fen and I took many birdwatching trips together and on one of them developed a unique system for sleeping. We would park his car sideways on a slight incline, get into our sleeping bags, put our feet out the window, and roll it up to the point where it held our ankles snugly.

In June 1953, I graduated from Mount Douglas High School, and Fen and I took off by car for California and Nevada. In Nevada we photographed nesting avocets, beauti-ful birds that we had never seen before. Near an avocet nest

3 *Pelicans at Zihuatanejo, Mexico*
pencil, 8 × 11 inches

4 *This is my first attempt at an oil painting. It shows a desire for impasto but no ability to achieve it.*
oil on canvas paper,
9¹/₂ × 13³/₈ inches

we set up a small tent and crawled inside. The avocets whirled around us shrieking but would not land. After a while, we decided that although avocets were undoubtedly sensitive creatures they probably could not count, so Fen left the tent alone, walked to the car and drove off. The birds immediately returned to their nests and I was able to take some good pictures.

5 RURAL CANADA *Farm on Mud Bay Road, Surrey, B.C. lithograph, 13 × 20 inches There seems an honesty and a strength in the architecture within the space.*

During this trip I shot rolls and rolls of small Nevada towns, western store fronts and abandoned mines, but due to a faulty mechanism in my camera most of them did not turn out. This sort of thing happens often and I have learned to be philosophical about it. It is a mixed blessing since it does force me to work strictly from memory from time to time.

Nevada is so barren and vacant that there is a strong tendency to be drawn to anything that relieves the emptiness—the occasional building, a cactus, or even a flower. Consequently, it is easy to miss the pervasive feeling of desolation which is the essence of this area.

When we returned from Nevada I entered the arts and sciences program at Victoria University, the beginning of a

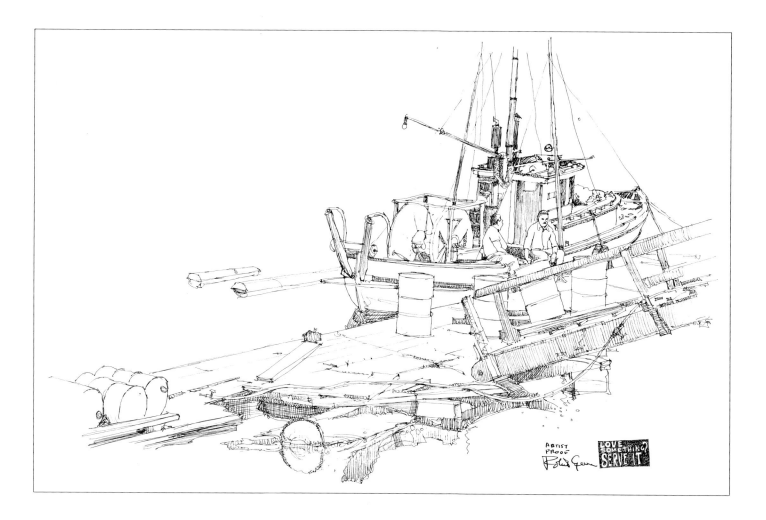

dark age for me. It was exciting to have new vistas of knowledge open up before me, but I found the system oppressive. Formal education attempts to train your thoughts to develop in one direction and I have always found mine moving in another. Extensive doodling in the margins of my notebook resulted in a rather poor performance in the final exams and I decided to take a year off and reassess the situation.

I took a job with J. H. Tod and Company, a west coast fish-packing firm, and journeyed north to Rivers Inlet, working as a deckhand on several fishing boats that were being towed in tandem by a pilot. One of the boats became disconnected during a bad storm and I had to jump from bow to bow carrying a line from one to the other — probably the most

6 GILLNETTER *lithograph,*
11 1/2 × 18 inches

dangerous thing I have ever done. The boats heaved up and down, the pilot not daring to come too close for fear of collision, but we were able to bring the boats in safely.

When we arrived at Rivers Inlet I began working at Beaver Cannery where I pitched fish for a few hours at night and tended the store for a few hours in the morning. My canvases were soon set up and my many free hours were spent painting the place. Beaver Cannery stood on stilts at the mouth of a creek and consisted of time-worn silvery buildings and raggle-taggle cabins that were strung along a wooden walkway. The manager of Beaver Cannery and his wife were art enthusiasts and before long several of my paintings had found their way into their home.

I used to chug around to various dilapidated cannery sites further up Rivers Inlet in a decrepit old one-cylinder gillnetter someone had given me. These old gillnetters, which are fast disappearing from the West Coast, are charming vessels with many endearing characteristics. They operate on a flywheel principle which only takes them about six feet a lick, but they are valued for their reliability. It is a shame that these old Easthope engines have gone out of style. Easthope one-cylinder engines now lie rusted and barnacled on the beaches of British Columbia, like tombstones for little boats that are no more.

When the fishing season at Rivers Inlet was over I moved north to Klemtu village where I was engaged as a cook and deckhand on a small fishpacker called the Tomahawk. Life on the Tomahawk was almost idyllic. Rising before dawn, I would start the Easthope (a three-cylinder this time), get it running nicely, and then make tea. The rest of the day was a matter of calling on the fishing boats, picking up their night's catch and keeping a tally of the different species caught. We went from boat to boat in fog and rain and infrequent sun. I did a great deal of drawing since the captain would not allow

me to bring my oil paints on board and by the end of the summer I had a large collection of fairly good pieces. It was a delightful existence with a sense of purpose to it.

While working on the Tomahawk that summer, I ran a little business on the side. The Department of Fisheries had just issued a proclamation stating that all boats must have their name and number lettered clearly on the side. Recognizing a

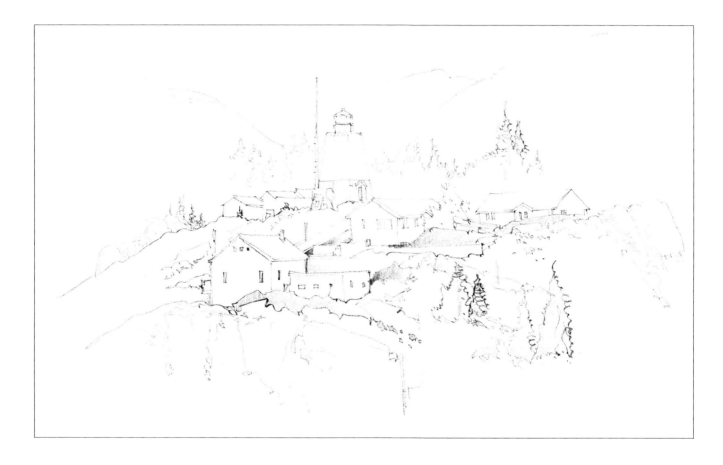

business opportunity when I saw one, I immediately wrote to my father requesting the necessary equipment and in due course received lettering brushes, some 'one shot' black, some 'one shot' red, and a maulstick. I began work at once; however, sitting on a wharf attempting unsuccessfully to letter a bobbing boat dampened my initial enthusiasm. But I persisted, undaunted, and soon developed a technique which at

7 WEST COAST LIGHT
lithograph, 11 1/4 × 18 1/2 inches

·11·

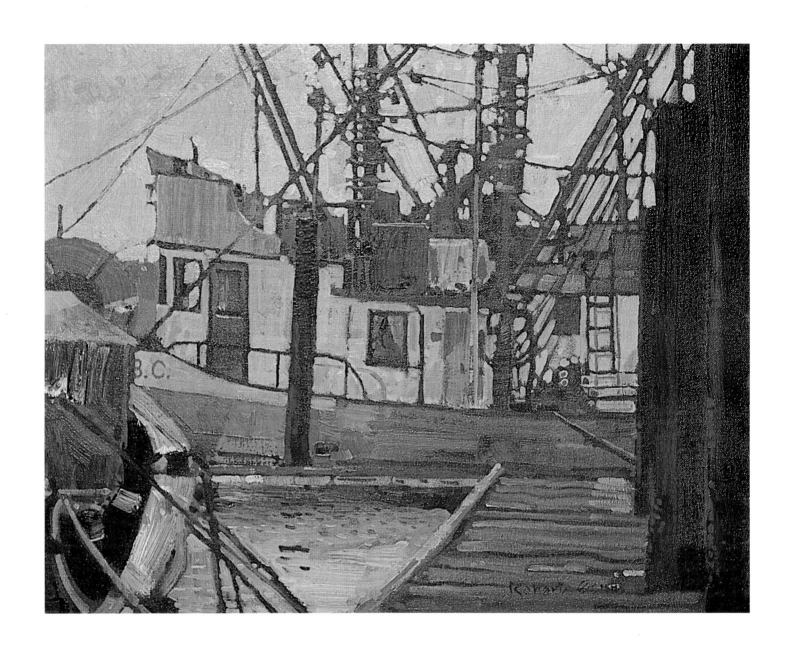

4 SEINERS 1967
oil on canvas, 16 × 20 inches

the time seemed like a small revolution in the art of boat lettering.

The trick was to do it all upside-down while lying across the bow. That way if the boat bobs or moves around at its mooring you go along with it. It did take some time to become accustomed to painting letters upside-down, but soon I had become so adept that I was able to add flourishes and embellishments which greatly impressed the fishermen. My rates were five dollars for the name of the boat and five dollars for the registration number. Word spread quickly and I soon had a lucrative little business going.

During the year I took off from Victoria College I worked for the *Saanich Star*, a small weekly newspaper that most of the residents of Saanich received in return for the grand sum of one dollar a year. My job entailed traveling from home to home collecting subscriptions and renewing them for another year. This was the ideal means of support for a budding artist because I could work when it suited me and I had a great deal of free time left for drawing and painting.

But what I particularly relished about this job was the opportunity to inspect other people's residences; a tremendous experience for anyone with a persistent curiosity about the lifestyles of others. I could drive right onto their property and look over their barns and outbuildings. There were inevitably some objections to such intrusive behaviour, but a perpetual grin and unflagging friendliness confounded most of the homeowners. I was able to process rapidly large numbers of people and places and become familiar with most of the interesting faces in the Saanich Peninsula. It was a very efficient way of gathering material and earning a living at the same time.

Art School

On the recommendation of a cousin who worked for the Chrysler Corporation, I applied to the Industrial Design Department of the Los Angeles Art Center School, and to my great astonishment was accepted. Without further ado, I put the Hupmobile in storage, packed my bags, and boarded a bus for Los Angeles. At last, I thought, an opportunity to excel after three undistinguished years at university. It was just a matter of time until my true ability would be recognized.

My first assignment at the Art Center seemed straightforward enough. We were required to produce 250 roughs of a theoretical design by noon. I began confidently filling up paper in my usual rapid fashion and was puzzled to find myself slowing down after doing fifty sketches. By sketch one hundred I had come to a complete halt. I had run out of ideas. A quick survey of the room informed me that others were working on designs that had not even crossed by mind! I had fallen prey to conventional thinking, and the realization horrified me.

With new resolve I returned to my work and forced my mind to operate in new and different ways. Before long I was turning out sketches as quickly as I had in the beginning and when the assignment was finished I felt I had only scratched the surface of the problem.

I had another rude awakening later the same day when we all took our sketches and pinned them up on the wall. I was not at the top of this class. It would be more accurate to say that I was at the very bottom.

The work load at the Art Center was heavy and I worked very hard, so when I began to see results it was even more gratifying. I discovered I had an ability to draw from life and a very good design sense. Colour classes gave me a great deal of trouble though. We would sit outside for hours, trying to

capture in acrylic paint the shadows cast by colour swatches pinned up in the California sunshine. The work was demanding, requiring precision and perfect balance, and I found it very difficult. I loved colour and was fascinated by its protean nature, but in spite of this I failed the course the first year.

I resolved to do whatever I could to develop my understanding of colour. Working evenings and weekends I gradually became sensitive to its variety, texture and emotional capabilities. Colours I had previously found weak and uninteresting—such as terra verte or raw umber—became new and exciting components in the sophisticated colour mixtures that I was learning to use. I discovered shades I never knew existed before, and began to have fantasies about discovering ones not yet on the colour wheel. I am always looking through bins of artists' colourmen to see if I can find a new shade to add to my repertoire, or combining several in an attempt to arrive at something new. For me, one of the beauties of oil paint is that you can take two pigments—yellow ochre and alizarin crimson for example—and stroke them on a canvas together in one happy mixture.

By the middle of 1958 I had run out of money and began to cast around for opportunities to earn extra cash. I managed, once again, to find a way of supporting myself that was also a source of great enjoyment. During my stay in Los Angeles I often attended the *concours d'élégance* that antique-car owners would hold in parking lots around the city. I have always loved cars. At one of these I displayed some careful renderings of classic cars I had done with Prismacolour pencils on black Canson paper. These drawings, which were stylized and illuminated as if it were by night or indirect sunlight, were an instant success with the car collectors. Phil Hill, a racing driver, commissioned drawings of his Jaguars and a Pierce Arrow that had been in his family for many years. One major collector had me draw most of the cars in his collection—

Bugattis, Duesenbergs, Lincolns, Rolls-Royces and Bentleys. Two or three car drawings a month were enough to keep me financially afloat and provided with first-class transportation (as long as I could persuade the owner to let me have the car in question for a few days). I would often cruise down Hollywood Boulevard on Saturday night driving an assortment of spectacular cars and soon developed a minor degree of notoriety that I found quite enjoyable. I was also beginning to appear around the occasional Beverly Hills swimming pool, sometimes in the company of certain Hollywood ladies.

This new high life somewhat impeded my academic progress and I found myself becoming disenchanted with the Art Center. Most of the people I knew there were destined to end up designing Pontiacs in Detroit, a future that held little appeal for me. The era of Raymond Loewy and Pinin Farina, designers who would singlehandedly create an automobile masterpiece, was long over. My feelings about Los Angeles were also becoming increasingly negative. The so-called 'good life' was losing its charm.

Around this time I began visiting a retreat known as the Fountain of the World. It was inhabited by nuns, patriarchs and priests of various stripes who lived communally, serving the community and sustaining themselves on supermarket leftovers. Three or four days spent in this place—sitting under the avocado trees, reading philosophy and conversing with the residents—would put my mind at ease. It was a well needed respite from my life in Los Angeles.

One day something inside me snapped. I had had enough. So I packed all my things in the trunk of my 1947 Cadillac and headed for British Columbia. Two and a half years at the Art Center had taught me a great deal. I had mastered techniques I had not known existed, and gained in strength. Looking back now, the Art Center seems like an ideal place for a young artist—too many roughs, though.

Getting Started

I returned to Victoria, took up residence in my old room on Persimmon Drive, and spent the next few months sleeping in late and renewing my social life. At one point it occurred to me that I might have some success in the advertising field and was soon engaged to design a billboard intended to persuade shoppers to go out and buy a certain brand of wieners. After giving the project serious thought, I filled the entire billboard with one giant wiener being carried off by several clever-looking, chop-licking, beady-eyed ants. I was very pleased with my efforts but the agency art director received my roughs unenthusiastically and unfortunately the campaign never materialized.

While looking for other work I moved into a dormer room in Vancouver's Point Grey district overlooking English Bay. There was a beautiful, quiet garden where I would set up my easel and paint quietly. I painted views of the garden, flowers and remembered scenes from the coast. Most of this work was done on twelve-by-sixteen painter's panels, academy board or plywood. Almost all of them were horizontal, with rough, angular skies done in thick paint. With the exception of a short period spent doing abstracts several years later, these were the most stylized paintings I have ever done.

In August I began to feel the need for a secure, indoor work space and I rented an inexpensive room above the New Design Gallery, which was, and is, a very *avant garde* place. The window of my little room had a direct view across Coal Harbour right into the muzzle of Vancouver's famous nine o'clock gun. At nine every night the gun would go off making everything in my room shake and rattle. This explosion became the starting signal for the commencement of my late-evening activities.

I bought lumber and built myself a studio set-up with easels, desks, and storage areas. There is no substitute for a

private work space. It frees the mind from mundane concerns and greatly increases productivity.

It was around this time that I decided to try and make my living as an artist. I believed that if I worked hard at refining my style and technique the money would somehow follow. A six-month period ensued during which I painted almost nonstop, eating and sleeping in my studio. The result was an incredible mess, and a few small paintings that I felt showed promise.

I made a list of the galleries in Vancouver in order of descending excellence and set out to call on them. The first found my work unacceptable, and the second said the same thing. The third gallery suggested I leave my paintings there so the owner could study them. I brought my paintings in and laid them out on the floor, then, finding the prospect of another rejection intolerable, I left them there, got into my car and drove away. A few days later, when I had already re-signed myself to a return to advertising, I received a call from the owner of that gallery. His name was Torben Kristiansen, and the gallery was The Art Emporium on Granville Street. He told me to come in and pick up my cheque because he had sold my paintings. This was the beginning of a long and fruitful relationship with The Art Emporium that continues to this day.

For a long time I had wondered if I would ever be able to support myself as a painter. I was beginning to be able to see how it was possible but was not yet ready to become a full-time artist. Archie Bell, a man who ran a small advertising agency, engaged me to do some drawings for a few of his clients: a local hairdresser, a jewellery chain, and other retail accounts of this sort. I spent a few months making older women younger, fat watches thinner, and small diamonds larger. Archie's business expanded rapidly, partly because I was able to do his drawings and layouts quickly, efficiently

and with a certain amount of style. I was beginning to discover that I had a definite flair for the retail advertising business, and although I never considered it my true career, it was good for me at that stage of my life. Archie made it possible for me to work whenever I needed to, and in return I met all his deadlines and produced good work. Being able to deliver is one of the greatest assets an artist can have. Talent is important, but delivery is really where it's at.

Archie strongly objected to the amount of painting that I was doing in the evenings and early mornings. I told him that as soon as I could clear seventy-five dollars a month as a painter I would no longer be available to him as an advertising artist. Archie thought that I would never make it, but only one month later I did, and I have never touched a commercial job since.

To be a painter is, to my way of thinking, the ideal life. You must be a bit of a self-starter for there is no one to tell you when to go to work. But when you love what you do, it is easy to begin, and you can keep at it as long as you want. For the first time in my life, I felt that I was free and independent.

I drove to the Okanagan, to the central interior of British Columbia, and the Cariboo. I painted inside my car and perched on the tailgate. While I was in the Gulf Islands I painted beside the car and on the running board. When it rained I used the steering wheel as an easel and when the sun went down I moved my gear to the motel room and continued painting there.

I became a paying guest of Mrs Lilybel Wood, a widow who lived in Point Grey, Vancouver. On nice days I would paint in her garden. Mrs Wood came from a wealthy Montreal family and had never lost the love for the better things in life. She was a great fan of the ballet, the theatre, the symphony, and was equally enthusiastic about art. Lawren Harris lived nearby and

was a friend of Mrs Wood's. Harris used to go for morning walks everyday, and so in order to meet him I began to go out at the same time. One day I fell into stride with him, introduced myself and told him that I was an artist. He replied by informing me that he was one too and then we began talking about painting. When he heard that I was having difficulty painting skies he gave me some very valuable advice. 'Turn

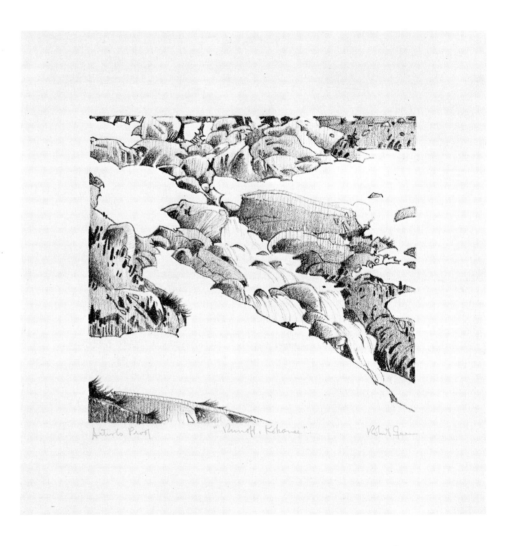

your picture upside-down, fellow! Paint the sky from the trees to the top of the picture. Paint down!' This had never occurred to me before, but it is a great idea. Painting upside-down helps you to control the gradation and enables you to work up into

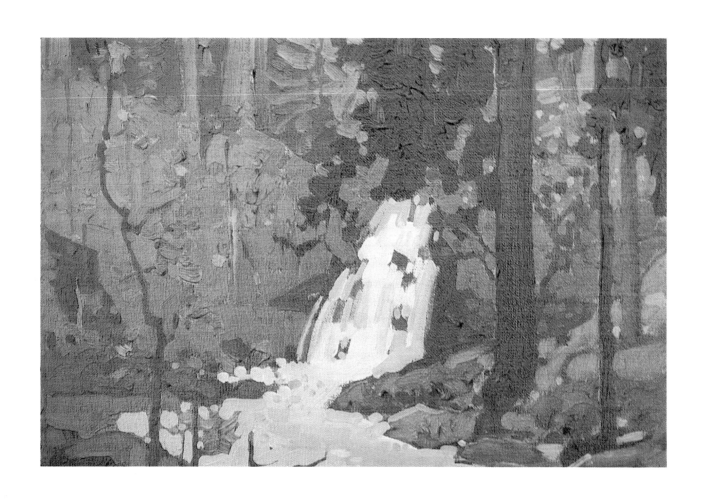

5 FALLS, KOKANEE 1970
oil on canvas board, 12 × 16 inches

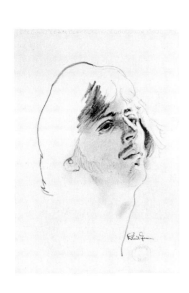

9 Drawing,
Vancouver Public Library
pencil, 9³/₈ × 9³/₈ inches

10 Portrait
pencil, 12 × 8¹/₂ inches

the trees in a more abstract manner. It is also easier to control the perspective of the sky when you are painting clouds. When you are doing clouds this way you are working from dark to light. It is less difficult than the other way around. Looking at Harris's paintings after this, I realized that this was how he painted them.

One day while I was staying with Mrs Wood, Carol came over to visit. Mrs Wood and I liked Carol immediately, and not long after Carol and I began to date steadily. The three of us would often drive out on Sunday afternoon to some pleasant spot near Vancouver. I would always take my paints along whether it was raining or not. On sunny days we would picnic, and I would paint while Carol and Mrs Wood had long conversations sitting on the grass. When it rained we would all sit in the car, me painting in the front seat while they played Scrabble in the back. This was a time in my life when I felt myself growing stronger every day.

Whenever someone asks me what I mix my paint with, I usually answer 'love.' If you can put a little love into it you can't go wrong, and during this period of my life love was in plentiful supply. I would work in my studio on Pender Street during the week, come home for dinner, go to plays or concerts in the evening and spend a lot of time with Carol. Kahlil Gibran said, 'Work is love made visible.' This seemed true at the time, and it has an even deeper meaning for me now.

By 1963-64 I began to work on larger canvases. Twenty-four-by-thirty, and twenty-four-by-thirty-six were common sizes, as were eight-by-tens and ten-by-twelves. People were important elements in my work at this time. I also gained inspiration and ideas working from various kinds of reference material that I would get at the public library.

Harry and Tim Howson, two Vancouver entrepreneurs who traveled regularly to the west coast for Indian art to be sold to museums throughout the world, offered me the

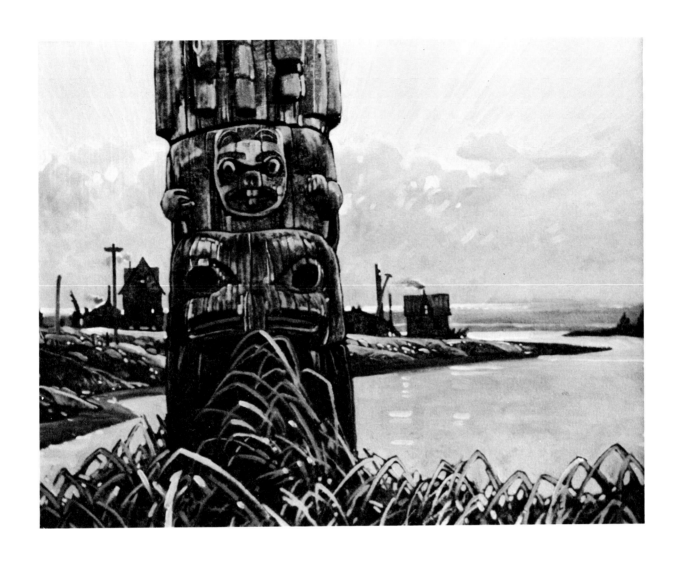

I I THE SILENT WATCHER 1969
oil on canvas, 20 × 24 inches

·23·

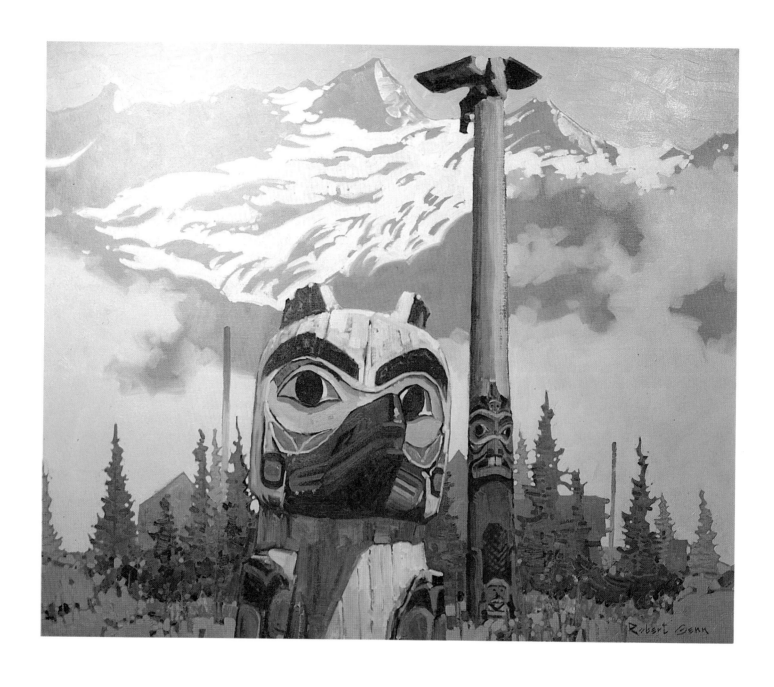

6 VISAGE WEST 1980
oil on canvas, 30 × 36 inches

chance to go with them to the Kwakiutl area. Together we traveled to Alert Bay, Kingcome Inlet, Fort Rupert and Guildford Island. At each stop Tim and Harry were greeted by the native residents as old friends. Tim carried a briefcase full of one- and two-dollar bills wherever he went. He was very fair with the native people when he was buying their things but it sometimes seemed as if he was shortchanging them due to the astounding rapidity with which these objects increased in value. Masks that he would pay $250 for were resold a year later for over a thousand.

This trip provided me with the perfect opportunity to become acquainted with old people who knew legends and stories from the past, and to amass quantities of interesting subject matter for paintings. I used to love reconstructing villages in my imagination as I thought they might have been fifty or seventy-five years before. Using the books of Marius Barbeau and Franz Boas, I was able to piece together an idea of what the deserted and overgrown villages were once like.

We moved from village to village, and I photographed every totem pole we encountered. This was the beginning of what was to become a personal archive of Indian material which now includes virtually all of the extant poles in British Columbia.

At this time I was experimenting with working completely alone and with other people. I discovered that I am much less productive when working with other artists (most of the artists I have admired have been loners), but total loneliness does not work for me either.

Paddy Newton, a friend of mine who owned a small amphibian plane would drop me off at different places for a few weeks at a time. One trip, to Savary Island, in the middle of winter, was a real experience. There was nobody else living on the north end of the island where I rented a small cottage for two weeks. Paddy flew me there, and we tossed back a

12 NATIVE CHILD AND
RECONSTRUCTED VILLAGE
1980
oil on canvas, 24 × 30 inches

·25·

glass of gin before he took off into the dark clouds and I began to work. The first day, I painted four rather good twelve-by-sixteens. The second day I did three and for the rest of the week I managed two a day. By the end of the week I was spending a great deal of time outside chopping wood, walking on the beach, pacing back and forth in front of my easel, and wondering what Carol was doing. I should not have paid that fellow for the cabin because he had a much larger woodpile when I left than when I arrived. Chopping wood was a mindless, menial chore that gave me genuine satisfaction—a bit like Winston Churchill building his brick wall, I suppose. The echo of the axe coming back to me through the wood seemed to fill the void and assuage the feeling of loneliness.

There is a syndrome peculiar to the life of the recluse; it has something to do with attention span—three or four days in one place is usually enough. Maybe the muse becomes eager for new surroundings and stimuli. If I were a different breed of artist I could have gained insight and inspiration from the beautiful area around that cabin. But when I had done the specific things I had gone there to do I completely lost interest in the area. I often rework ideas, doing my own variations on a theme, but once I have put a great deal of energy into capturing a given scene or vista I become restless and prefer to move on to something else. This need for variety can also apply to the media I work with. Working mostly in oil, I found it a nice relief to do a few watercolours now and then. An artist can become stale working in one medium for a long time.

By August I was back in my car touring the B.C. interior and painting on a more mobile basis. As a means of seeing, you really cannot beat the private automobile. It is easy to position yourself in exactly the place you want to be, or to 'mix and match,' painting a foreground in one area, moving the car a couple of hundred yards and then finishing the panel

from a different perspective on the same scene. I produced copious quantities of eight-by-tens and ten-by-twelves during this time, using a system that I still use today. I begin a panel on location, put it in a 'wet box' for a while, and bring it out later on for a thorough evaluation before it is finished. After a trip where fifteen or twenty paintings have been started, I bring them back and lay them around on the floor of my studio and decide which ones to work on. Some can be finished quickly and easily, and are fun to do. Others produce anxiety and require a prolonged period of gestation prior to their completion. There are always a few that nothing can be done with and they go into my permanent collection of rejects and failures. They are difficult to throw away because whatever it was I initially saw in the subject still holds an appeal and there is always the hope that some day I will find a way to finish the composition properly. There are now at least a thousand of these unfinished paintings, and the collection continues to grow steadily.

Europe – The First Time

On August 29, 1964, Carol and I got married. She had been a stewardess and I was tired of getting postcards from far away places. I had always wanted to go to Europe and now was my opportunity. We flew to Amsterdam and spent the first few weeks in Holland living in a third-floor walk-up hotel near the Rijks Museum. I painted along the dikes of Amsterdam, canvases with low horizons and great yellow-grey skies.

In order to gather lots of reference material on our year-and-a-half-long trip through Europe, I instituted a simple and economical system for taking inexpensive photographs. I used a small 16mm movie camera which I could single frame and take daily records of thirty, forty, and fifty pictures. With two thousand individual frames on a roll, it was very economical

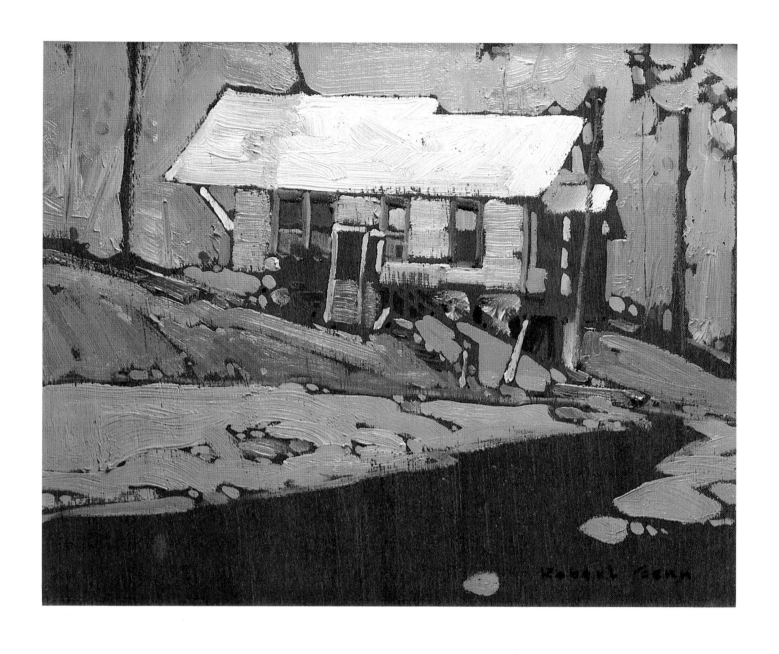

7 HOUSE, DOLLARTON, B.C. 1980
oil on panel, 8 × 10 inches

indeed. During our stay in Europe I used five rolls. I recorded a picture of the date at the beginning of every day, so that I was able to organize these reference photographs efficiently later on.

We flew to Frankfurt towards the end of September and purchased a used VW bus for five hundred dollars. In two or three days, we had the vehicle fixed up as a mobile studio and home and took off in the direction of Ulm, Augsburg, and Munich in Bavaria. Carol insisted on her creature comforts and did not much like the idea of roughing it. As a stewardess she had become accustomed to staying in first-class hotels with lavish bathrooms. So, to compensate partly for our primitive lifestyle, I bought her a large plastic tub which we carried on the roof of the VW. Other campers could always recognize us from a distance because of that tub. I lettered 'Canada' on the back of the bus and we were greeted in a friendly manner wherever we went.

We drove through Austria, Italy and Yugoslavia on our way to Greece. In Greece we camped for a few weeks near Sunion on the south coast, and I painted several fanciful land-scapes with the olive trees and beautiful beaches that are found in that area. I was staggered by the brilliance of the sunlight in Greece. It was here that my education in the nature of shadow began in earnest.

On our way back through Italy I did several drawings around Bari and Brindisi. We continued on to Naples and then spent several days in Capri where I was able to turn out some passable scenes of concentrated houses that looked as though they were tumbling down the hillside toward us, and of the beautiful little bay dotted with bobbing boats.

Carol and I camped for a few days in the mouth of an ancient volcano in Pozzuoli in Italy. The place had several fumeroles which bubbled and burped and steamed most of the time. It smelt of sulphur, and there were cats everywhere. I

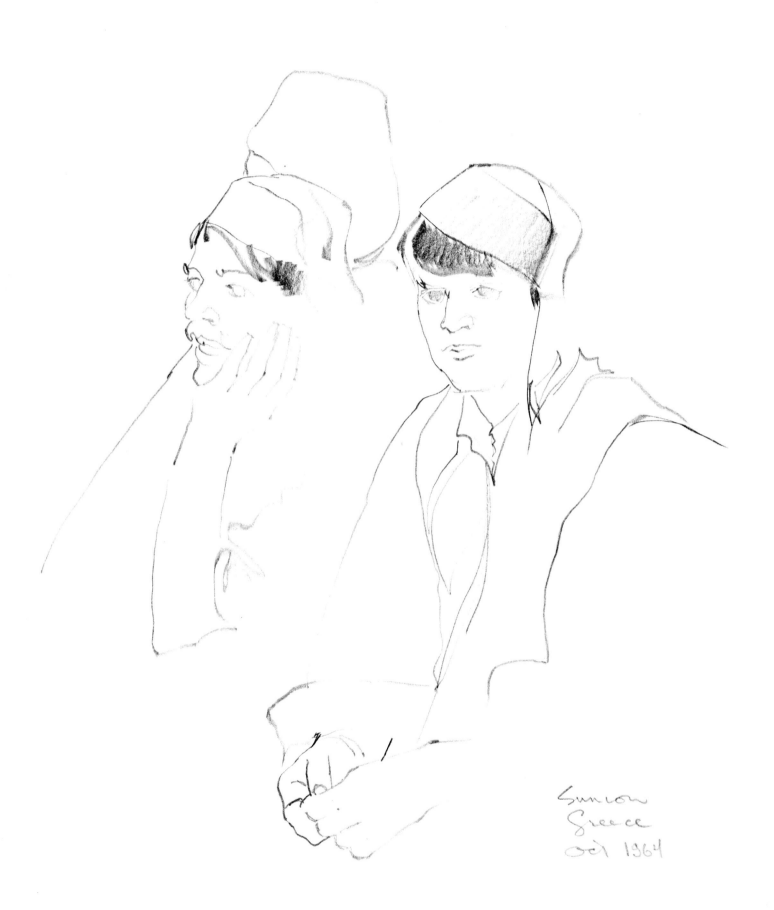

Simon
Greece
Oct 1964

had been painting on Capri and around the Amalfi coast and had a lot of half-finished paintings which I was trying to complete. I carried only a few stretchers with me and would remove paintings, roll them up when they were dry and stretch new canvas on the frames. Sometimes when my work got a bit ahead of me, there would be wet paintings hanging up in the VW van like bits of laundry on a line, which made it difficult to get in and out. I took advantage of the smooth, round trees that overhung our campsite, and tacked the wet canvases to the trunks of the trees to dry. This was before I started using cobalt driers in my paint, and they sometimes took weeks to dry.

At night the cats around the van made a terrible ruckus. They were always noisy but one particular night it became unbearable and I decided we would move at dawn. Upon emerging from the van the next morning I was horrified to find my carefully executed renderings of the area transformed into abstracts. The cats were in the habit of running up and down those trees at night and traction had apparently been poor in those areas where my paintings were hanging. I caught one of these midnight abstractionists and cleaned him off with turpentine. The cat howled in anguish and outrage, but I think he learned not to attempt to dabble in art again.

When it began to turn cold in Italy we headed for the south of Spain and arrived at the Costa del Sol by November. We traveled around Malaga and Torremolinos and found the little village of Fuengirola so appealing that we rented a fine home above the Mediterranean just beyond the village. There was excellent birdwatching in the vicinity and lovely scenery. A sparsely populated rural area surrounded the village and I discovered a marvelously paintable town called Mijas a mere twenty minutes by car. Mijas was truly an Andalusian gem — little, white-washed houses with red-tiled roofs and potted geraniums on the window sills, winding narrow streets and

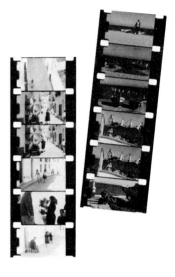

13 *Sunion, Greece,* 1964 *pencil,* 10³/₈ × 9 *inches*

14 *16mm film strips from a Filmo camera. I viewed them by putting them in the gate of a standard 35mm slide projector, or by using a magnifying glass against a window.*

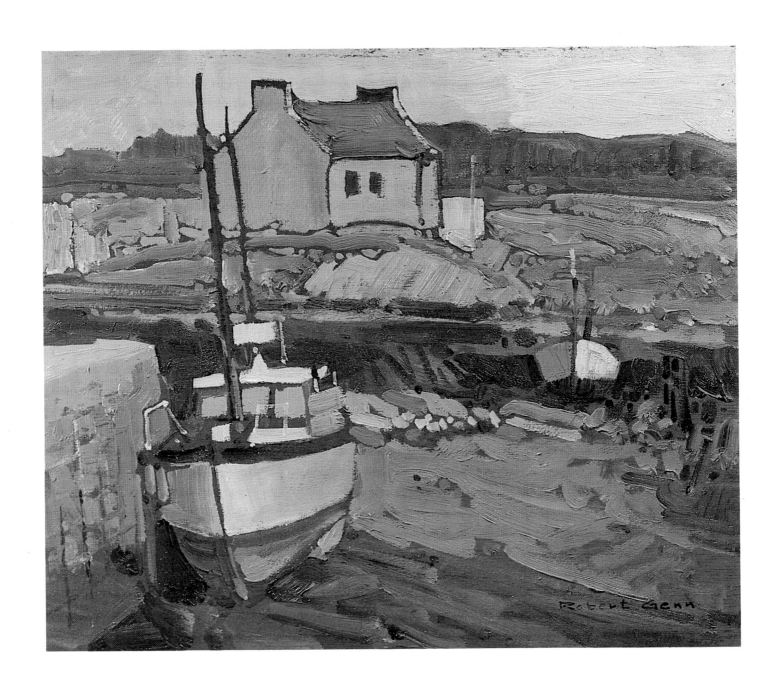

8 QUAYSIDE, CONNEMARA 1969
oil on panel, 10 × 12 inches

steps, and the sound of different caged birds singing at you from the sunny walls.

On New Year's Eve, 1964, I sat looking out of the window of our rented home, watching the festive fireworks at the Mare Nostrum hotel below us. I wondered if it would be possible for me to market some of my paintings to the tourists who stayed there.

The following day I went to the hotel and arranged with the manager to take a small room off the lobby of the hotel where I could set up a modest art gallery. I had almost no money left and was running dangerously low on canvas, paint and frames. I negotiated the deal with no money down, agreeing to pay the manager twenty percent commission on everything that I sold in the hotel. When I translated the agreement from Spanish to English for Carol's benefit, she asked who was running the gallery for me when I was painting. I told her she was. Carol had never done anything like this before but she was willing to learn. I purchased paint, canvas and frames on credit and in a few days I had produced some work which I could put in the gallery. In keeping with Spanish custom, we opened the gallery at about 9:30 am and closed again at noon. At four, after siesta, we re-opened and remained open until nine at night. The gallery looked very attractive with fifteen or twenty paintings on the walls and we were pleased with it. A week went by and there were no sales at all and we began to feel very discouraged. One day Carol came home and jubilantly covered the dining room table with pounds, kroner, pesetas, francs, guilders, and Deutsch marks. A northern European tour group had arrived and practically bought us out. She had sold eleven paintings in one hour. We celebrated with a bottle of 1936 Chablis.

There were many artists in the village of Fuengirola and we became friendly with most of them. Some were ex-patriot Englishmen with small pensions, living the semi-bohemian

life of a painter in sunny climes. They were all amazed that anybody would attempt to sell paintings in a place like Fuengirola.

These fine people talked a great deal about art and many were capable of producing good work when they wanted to, but the gorgeous weather, inexpensive wine and plentiful companionship were very powerful distractions indeed. Fortunately, I have been blessed with a natural desire to paint. I have never had to force myself to work and am usually very productive. Productivity is a very important component of success. One Englishman that I met painted only one small canvas a month on which he spent a mere two hours. He could hardly be called a working artist even though his work was of a professional calibre. To be a successful apple vendor you must always have apples in your cart.

The ability to work hard at the thing you love is a tremendous advantage in life. I used to have a sign that hung inside one of my old cars that read, 'If you love something, serve it.' When you stop serving the thing that you love, your level of accomplishment declines. One of the surest ways to stop serving the thing that you love is to talk a great deal about serving it. This expends valuable energy, every ounce of which is needed for the task at hand. This bit of advice is worth several million pesetas. I am giving it to you here free of charge.

One of the problems that we had living in that pleasant home on the hill in Fuengirola was a constant stream of visitors, mostly from Canada. People who wouldn't walk across the street to say hello to you at home will travel thousands of miles to visit you when you live in some faraway exotic place.

I have always been able to walk away from a social situation and go off on my own, so visitors didn't interfere with my work too much. For me my room is sacrosanct, a place for the

private pleasure of work and silent contemplation, not for the forms and amenities of society. Poor Carol was often left alone to entertain my friends and relatives when I went off to paint. Other artists did not interest me either, unless I felt a deep respect for their work.

At the Art Center we were encouraged to keep in our morgues only the first-class material and to reject everything else. Doing this maintains the quality of your available work and eliminates the possibility of mediocre pieces finding their way into the marketplace. Second- and third-rate art are popular currencies these days and it is important not to allow yourself to be swayed by the money it can command and compromise your standards.

One day, while walking near the village of Fuengirola, I saw in the distance a man standing on a bridge doing a large easel painting and having his shoes shined by one of the locals at the same time. He struck me as being the very epitome of elegance, and, intrigued, I decided to try and have a look at his work. I circled around him and, angling in, finally gained a view over his shoulder. The painting was ghastly, but the artist interested me so much that I decided to strike up a conversation with him. I told him that I was also a painter and asked him if he knew where I could buy frames. Speaking with an English accent, he told me that he felt that his work was not good enough to frame and that consequently he did not know where to find any. 'You don't paint for a living, then?' I asked. 'No,' he replied, 'I am a rock crusher.' Even more fascinated, I asked him to come along with me to the mountain village of Mijas where I could show him some effective views. Again he denegrated himself by saying he was not good enough to paint excellent views, that he was just a hobby painter and, besides, he had a wife and children nearby and would only be a burden to me. I told him that was

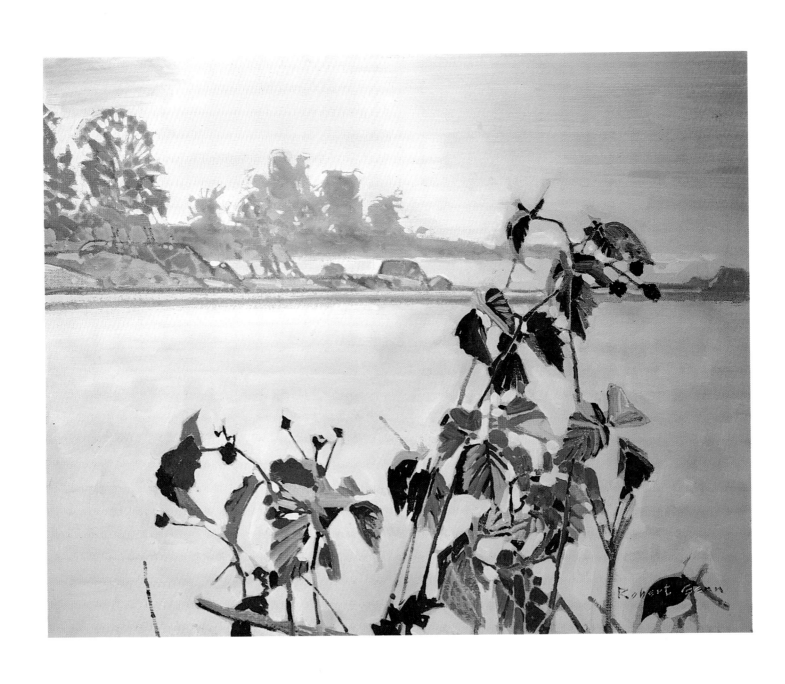

9 EDGE OF THE BRIGHT LAND 1977
oil on canvas, 16 × 20 inches

nonsense and offered to pick him up at one o'clock. Finally he agreed, and we had a delightful day at Mijas. A friendship developed, and we continued to paint together for several weeks while he was in Spain.

We met many interesting people in Spain, and they all made a lasting impression on us. A painter from France, Maurice Golleau, walked into our gallery one day and asked to speak to me. He said he had come with the express purpose of showing me how to paint and offered to give me a few lessons. He was a strong-willed, forceful individual and I was quite taken with him. We went to an area on the Rio Fuengirola where before my eyes he painted a very creditable landscape with my materials. Golleau employed a technique best described as 'rapid scumbling.' This consisted of pushing and twisting large brushes forcefully against the paint as if he were scrubbing the canvas. His work was characterized by an overall softness of focus and evidently he thought mine should be too. I have always been concerned with design, pattern, and achieving a hard edge. Mine were hard-focus paintings. Golleau was a borderline Impressionist.

Since he refused to speak English, I could only understand whatever my limited French would permit. However he did make me see one consistent fault in my work that I had previously been unaware of. According to him my paintings lacked a specific focus, everything being rendered with the same amount of detail. What most people see when they look in a particular direction is one or two areas in sharp detail and the rest in a bit of a blur. Artists examine everything individually and then paint, and may tend to forget this fact. Golleau's entire canvas would be fuzzy, with just the slightest sharper centre of interest in the painting. Looking at Golleau's work later on, I noticed that they were not like the ones he painted for me. These must have been painted as lessons which he felt I needed.

Every minute spent painting is a learning process. The more you learn the more the process itself accelerates and intensifies, and the more the experience of painting becomes heightened. There is nothing more destructive of creativity than locking into some formula or concept and turning out identical paintings, one after another, like cars coming off an assembly line. Individualists like Monsieur Golleau had their learning process refined to the point where it became translated into a personal style. There was the distinct impression of quality in his style which was unique because it was self-discovered and self-taught. These are the things that one artist can admire about another. There is always quality in true style.

When I had been living and working in my small studio above the New Design Gallery in Vancouver, I would sometimes go below and look at the abstract expressionism and minimalism that was popular then. It would always reinforce my determination to do work that would last, and that would be the product of feelings as well as the result of technique.

My feeling about art schools is that they too often produce artists who are merely imitating their teachers. Students graduate with their style preformulated for them. A style is an individual mode of expression that is only achieved through much soul-searching, dedication and hard work. Monsieur Golleau had a definite idea of how his landscapes should look that grew out of his personality and the years spent developing and refining his art. The result was both beautiful and unique. 'Start with a style and you are in chains,' said Richard Avedon. 'Start with an idea and you are free.'

By the late spring of 1965 it seemed time to leave Fuengirola. I had painted everything in sight—the gardener, the gardener's father, the gardener's wife, and aunt. I had painted donkeys carrying loads of sand up from the Mediterranean, and the

castle which was surrounded by poppies in the spring. My work room in Fuengirola had been turned into a disaster area, and it took me a week to clean it up. Marks on the walls where I had taped up reference material were quickly painted over by the maid. In Spain, particularly in Andalusia, they are always repainting their houses, inside and out. This results in beautiful soft shapes that form around the doors and windows over the years which lends a particularly interesting aspect to their design.

We put our accumulation of things into the VW and headed north. We located El Greco's view of Toledo, and I painted a similar picture from the same vantage point in the sizzling heat. We visited the Escoreal, then on to Madrid, and the Prado Museum. For two days I concentrated on the paintings by Goya and Velasquez. The latter's work surprised me with its fresh painterly quality. The galleries of Europe had been an enriching experience for me in the past, sometimes with mind-expanding results. Seeing great works of art in the original for the first time is always exciting. It gives me the opportunity to confirm my imagined idea of techniques used by artists I greatly admired. But the real visual revelation of Europe was the scenery.

We visited the small town of Guernica, the name of which has been identified with a turning point in the history of western art ever since 1937 when Picasso exhibited his painting of the horrifying Spanish massacre that occurred there. We watched Basque families netting eels in the river which runs through the town, and I couldn't help but imagine Heinkel 1-11s overhead, and plummeting Stukas showering explosives on the innocent children and elderly.

We visited Paris, and I spent a week just walking around and taking it all in. Paris makes me think of romance, history and great art. Montmartre is full of lovely, quaint buildings hung with plaques informing passersby that here stands the

former residence of Van Gogh, Gauguin, or Toulouse-Lautrec. I thought back to that doldrum year between my first and second year of college and wished that I had had the initiative and sense of adventure to live the artist's life in Paris. One year spent in Europe at the right time of life is worth any number of years spent listening to lectures.

Crossing the Channel, I painted my first view of the white cliffs of southern England from the boat. England is a magic land for me, a 'sceptered isle.' After a short stay in London, we traveled north to the tiny perfect village of Bradbourne in Derbyshire where we were the guests of Bert and Eileen Wallis whom we had met in Fuengirola. Eileen's father was ill at the time and we were asked to stay and look after their children so that she could be near him. I used Bert's spacious studio which overlooked the Derby dales. In the VW we explored the Peak district and the surrounding area. I loved the grey buildings made of Derbyshire limestone that fit into the landscape as if they were rooted in it, and the crumbling rock walls arching over the hillocks, dividing up the green countryside. The intelligent use of space and carefully regulated improvements made over the centuries have preserved the natural beauty of this area. Powerlines nestle in valleys out of sight and large quarries are hidden behind hills. Industrial towns such as Sheffield, Stoke-on-Trent, and Leeds do not suffer from the urban sprawl endemic to North American cities. The country is only five minutes from most of these towns and on Sunday mornings thousands of English families drive out to these beautiful areas to enjoy the solace of the scenery. At Arbor Low and Dovedale, I painted and drew, and put my feelings into modest attempts at poetry.

While we had been living in Fuengirola, I had begun a series of abstract paintings, partly as a hobby and partly as an exercise intended to develop my design sense. I set specific perimeters

15 *Sketch of buildings in Derbyshire, U.K.* pencil, 11 × 15 inches

10 AT THE KLEMTU WHARF 1979 *oil on canvas*, 30 × 36 inches

11 *Detail from* AT THE KLEMTU WHARF

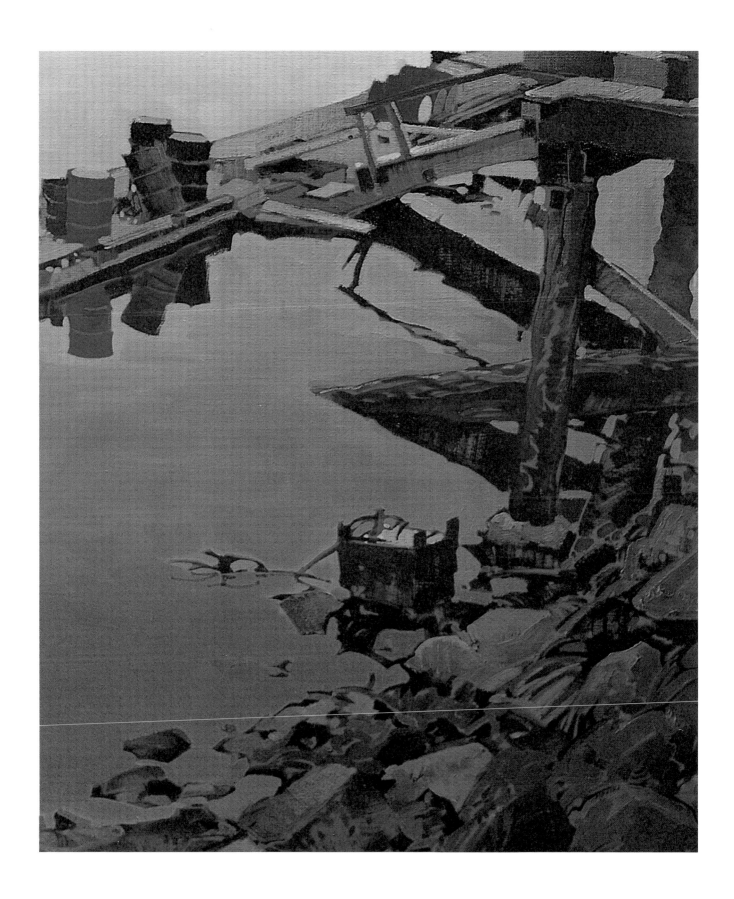

on the size and style of these works; with the exception of a few they were all on eight-by-ten panels. I used to have dozens of them propped up around the house in Fuengirola, and the constant parade of guests allowed the opportunity of observing various reactions to these paintings. They were all numbered, and I would ask visitors to select the ones they felt to be the five best and five worst. I was surprised that most people chose the same best and worst. I kept score on the back of each panel. It is amazing that opinions from such disparate sources can be so similar.

I continued to paint these small abstracts while at Bradbourne and they were exhibited in a London art gallery. While initially an interesting digression from my usual style, I began to be bored by them. They did not seem to offer enough challenge. A perfectly pedestrian painting of a Derbyshire limestone cottage surrounded by oak trees with rolling hills in the distance has the same essential components as the abstracts, but it has the additional element of possessing a recognizable reality to its subject matter, plus a feeling of depth, greyness to rest the eyes, gradation, colour, a busy area and areas of empty space. When surveyed with half-closed eyes, good paintings of all genres have the feeling of abstract design about them. Overworking or overdetailing subjects can destroy this by becoming too intent upon reproducing reality. It is best to formulate even your most complex ideas in the simplest, most straightforward design pattern possible. Painting abstracts has been an educational exercise, and my work profited from them.

We visited London several times, returning to get another look at the Turners in the Tate, visiting the British Museum and taking in the special atmosphere of the city. We traveled to the south coast of England, crossing to Holland, and then driving to Copenhagen where I exhibited my work for a couple of weeks on invitation from a traveler I had become

acquainted with in Spain. At a party one evening, I happened to mention that I had always wanted to see Norway and a Danish lawyer there invited us to stay in his cabin on Christianafjord on the island of Speroi.

Two days later we arrived in Speroi. A more golden October could not be imagined. Low, rock-clinging trees,

16 *At Speroi*
Nothing is as much fun as
mucking about in boats

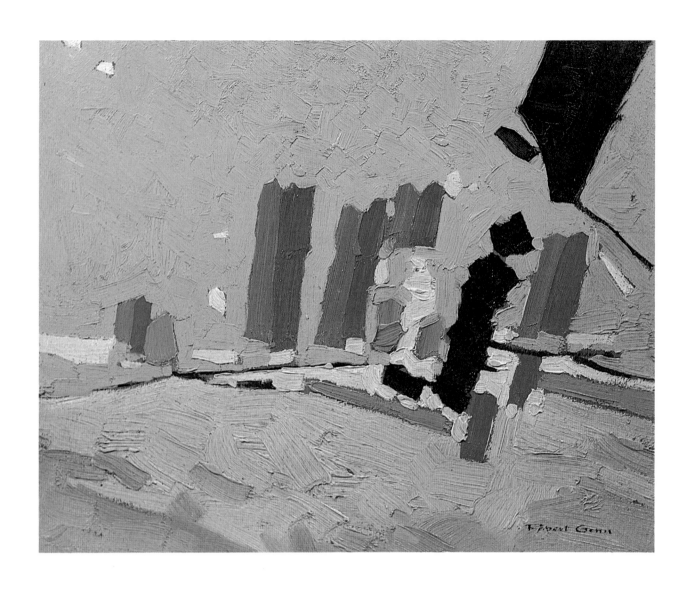

12 FLAGS 1965
oil on panel, 8 × 10 inches

gracefully glaciated rocks, endless shorelines, dignified houses crammed together on the edges of the bay, magnificent double-ended fishing boats, and the rustic ruggedness of the local people all contributed to the charm of this island. I returned to painting the north. This area was like a more sophisticated northern Lake Superior landscape with colour and space between the trees. We lived in a small rustic cabin at the top of an abandoned garden. For our provisions we traveled in a dory, which we rowed standing up, Norwegian-style, to a seaside store a quarter of a mile away. We purchased mackerel from the local fishermen and dug potatoes in the garden. Our life was like a series of scenes from Ingmar Bergman's *Wild Strawberries*. For me the place was magic with history. Edvard Munch lived near here at one time, and the surrounding area was filled with images found in his work. We spent a month on Speroi, climbing rocks and painting pictures, many of them within a hundred yards of the cabin. One day, from the bluff overlooking the fjord, I saw a partially submerged submarine, like a giant shark, proceeding down the inlet. The idyll was broken; it was time to go.

We made our way south again, pausing to visit friends around Copenhagen for a week, and then proceeded to England. In Bristol, we booked passage on a freighter to Montreal via Halifax. We were heading home to Canada. In the last days of November, we sat on the quay in Avonmouth and watched our VW being lifted aboard the freighter. Three other passengers joined us on the boat. It was to be a rough crossing.

The freighter had arrived in Bristol full of grain from Canada and was proceeding back with automobiles and other goods. Quite a bit of grain was left on the deck and, as we proceeded down the Severn, hundreds of shore birds from England, including wrens, sparrows and robins joined us on our journey. Some of the birds left as we passed Lundy, but

after two days at sea many of them were still on board. Sometimes, the grain being nearly exhausted, the birds would take off and leave the ship with no land in sight. Some would fly east, others north, some south. They seemed to know not to fly west. At other times, they would return wearily, having flown miles away from the ship without seeing land.

When I began to find dead birds on the deck I started an all-out campaign to look after them, taking bacon and cereal from the ship's galley to feed them with, but it was to no avail. The birds seemed to know that they were getting out of their territory and that they had made a fatal mistake. I just about went crazy trying to keep those birds alive. On the tenth day out there were no birds left on the ship.

In the roaring gales that accompanied our passage, I worked my way around the foredeck, clinging to the life lines used by the sailors. The captain was heard repeatedly on the public address system urgently requesting that Robert Genn return to his cabin. He could see me out there on the bow of the ship as she plunged into the formidable Atlantic weather and he feared a lawsuit if anything happened to me.

Carol was sea-sick for eleven days. I can remember lying in my bunk on one side of the cabin watching Carol looking out of the porthole from her bunk trying to get a fix on something stable. The carpet on the floor would roll up and unroll, again and again, as easily and automatically as if it had been doing it for fifty years. Once, while taking a bath, I had the unique experience of having all the water jump out of the tub at one time and run up the wall of the bathroom. It was a disconcerting trip. At last, we sailed into Halifax harbour, and we spent a few days in Nova Scotia while the ship was unloaded. It was my first look at the Maritimes. We traveled around the Gaspé, past Anacosta and up the St Lawrence to Quebec City in the morning mist watching the Citadel rising out of the fog above

the river. On the second day we arrived in Montreal, and our honeymoon odyssey was over.

Home in Canada

But a new adventure was beginning. It was fifteen days before Christmas, and we were going to drive the VW across our vast country in the middle of winter. After the short distances and easy passages around Europe, we were on the 'big lonely.' I frequently wanted to stop and paint, but in order to make it back to Victoria and my family by Christmas, I had to limit myself to one a day. In Algonquin Park, it became unbearably cold. Sleeping in a van in sub-zero weather is not advisable if comfort is at all important to you. At Canoe Lake, where Tom Thomson drowned, our toothpaste froze, and a bucket of washing water beside the bed in the van was solid ice. In the morning I felt like someone had a vise-grip wrench clamped to my nose. I jumped into the front seat and snapped on the gas heater but it was a good half hour before the temperature was above the zero mark. With the heater on full blast, and wearing a pair of lined leather gloves, I did an eight-by-ten of Canoe Lake. I did paintings around the Montreal River area in northern Ontario, near Rainy River at Atikokan, and in several locations across the Prairies. Later from these paintings, and others that developed out of them, I was able to assemble a show which was called 'Canada in Winter.' The dealer was annoyed with me for hauling so many tons of snow into his gallery.

After a pleasant Christmas reunion with my family in Victoria, we decided to move back to Vancouver. In January 1966, we moved into a suite in a duplex at 96 West 18th in Vancouver. This suite had one small room at the front, approximately ten-by-ten with a very high ceiling. I was in

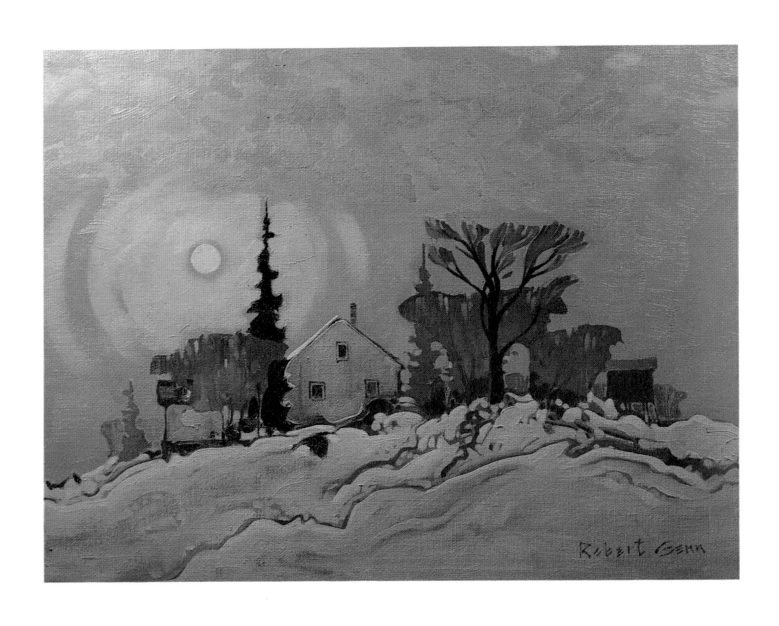

13 CANADA IN WINTER 1979
oil on canvas, 12 × 16 inches

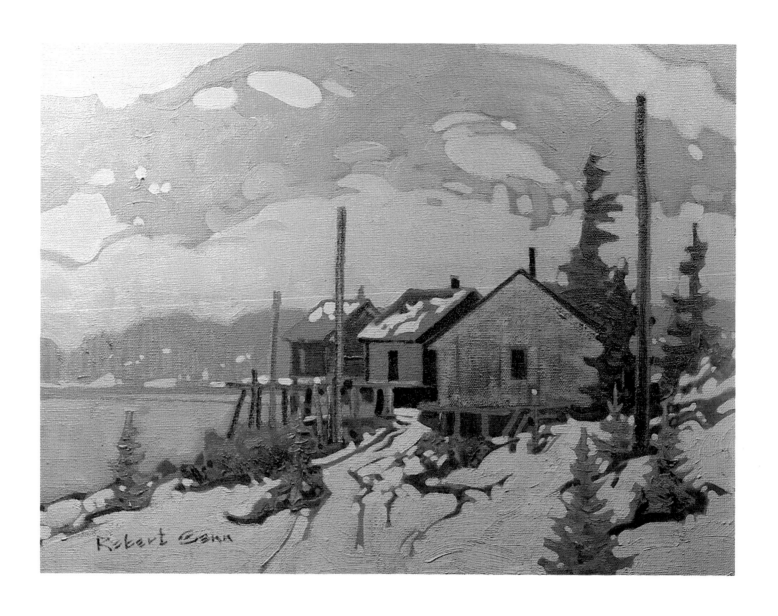

14 CAMP 1980
oil on canvas, 12 × 16 inches
An oil which served as the basis for the serigraph KWAKIUTL.

the mood to be grandiose and was quite anxious to do something monumental. I produced a couple of canvases, in that mood, that were nine-by-nine feet. It is possible to do large paintings in small rooms but not without experiencing certain difficulties. Getting them out of the small room meant they had to be removed from their stretchers, rolled up and reassembled on the outside.

In Europe I had been steeped in the legacy of a thousand years of easel painting and had become aware, through countless visits to innumerable galleries, of the diversity of styles and techniques used in the past. This new knowledge gave me a renewed understanding and love of my own country as well as a new way to express that feeling. I had painted in different parts of the world where the sun shines in varying degrees of intensity creating different highlights and shadows. I felt I had now mastered light and could include it or leave it out as I wished. Unlike in Mediterranean art, direct sunlight is not always a necessary element of Canadian landscape painting. Furthermore, Canadian landscape artists, particularly the Group of Seven, have developed a unique way of capturing the essence of the terrain they paint. They condense the vastness of Canada onto small panels, a task which requires redesigning the environment to give it an art nouveau, two-dimensional quality.

I have always felt that the small works of Tom Thomson, J.E.H. MacDonald and Varley in particular expressed the intrinsic feeling of the Canadian landscape and perspective. They were less effective in their somewhat overworked larger pieces. This is a problem common to many Canadian artists, myself included.

I decided to take my European experience and superimpose it on my feelings about the Group of Seven and other Canadian masters, in an attempt to evolve a new, personal understanding of the Canadian landscape. I became attracted to the

beauty and sparseness of the work of David Milne. His dryness, openness and the strong, distinctive brushwork were qualities I coveted. I wanted to do something Milne-like but with an additional richness of light. I wanted to adapt his style to convey the unique condition of western Canada on a canvas.

We made the VW bus over into an improved, mobile studio. I took out all of the sleeping equipment and put in a desk, a permanent easel, and a comfortable chair on rollers that would be easy to propel back from my work in order to evaluate it with a minimum amount of effort. The bus had many windows, and I frequently used them as imaginary frames when picturing views from inside.

We took a trip to the Skeena Valley in the rain to visit the Indian villages of Kispiox and K'San, Kitwanga and Kitwancool, all of which had weather-beaten totem poles still standing. I felt I was seeing these places for the very first time through the windows of my European vehicle. Some of them have changed very little from the time A.Y. Jackson and Emily Carr were there in the twenties. The general greyness, the rugged backgrounds, and the monotony of the forestscapes are even more meaningful and unique when viewed from the same window through which I had painted the Champs Elysée and the Victoria Embankment. In this improved version, I used the VW all over Canada during the next few years.

Northern, central, and coastal British Columbia has always been my spiritual home as far as painting is concerned, especially when the atmosphere lends a brooding aspect to the landscape. But by November, which gets very dark in Vancouver, I was feeling the need for bright sunlight, and we decided to go to Mexico. Mexico is a special place unlike anywhere else in the world. A brilliant country with lovely

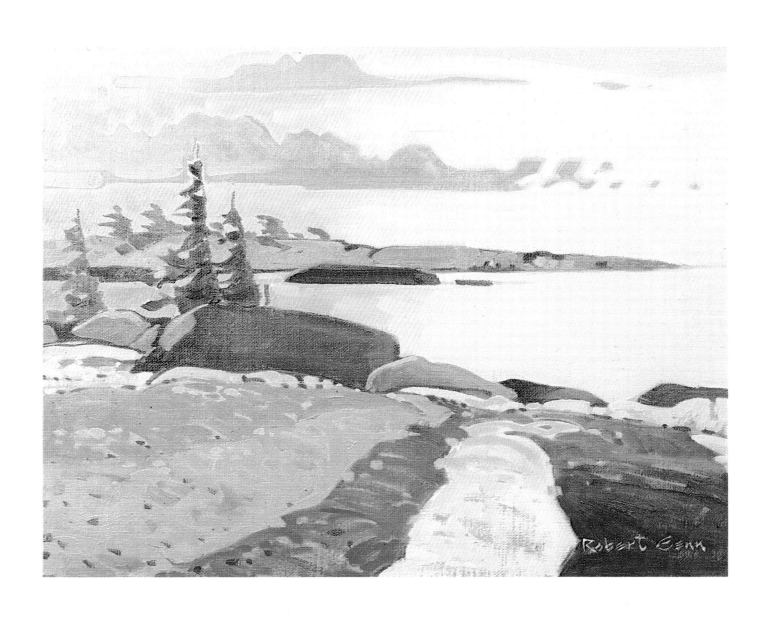

15 GOLDEN AFTERNOON 1978
oil on canvas, 12 × 16 inches

people and a mysterious ancient culture still in evidence, it fascinated me from the very start and we have returned there almost every winter since 1966. Mexico City and Guadalajara are thriving metropolises teeming with people, colour, sound and unique combinations of the very old and the new. We went to Puerto Vallarta for a rest and for some excellent birdwatching. It was here that I began painting the Mexican people.

An old Buddhist saying, 'An inconvenience is an unrecognized opportunity,' is perhaps more true for a painter than it is for anyone else. Because they can carry their equipment with them all the time, they can work anywhere. Waiting for trains and ferries can be an ideal opportunity to stretch your mind and methods by attempting to capture the surroundings on paper or canvas. If you maintain flexibility you can discover some surprising things in unexpected moments.

In April of 1966, Carol and I decided to move out of Vancouver to a quieter, more rural area where we could still get to the airport or the city to avail ourselves of the urban amenities. For a couple of months, we explored the nearby towns and suburbs of Vancouver looking at Squamish, Mission, Chilliwack, Abbotsford, Aldergrove, and Ladner. Eventually we decided on White Rock, a small town only thirty miles south of Vancouver, near the United States border.

Sunny and warm, White Rock has many of the attributes preferred by most artists: the sea, fresh air, and an abundance of interesting subjects at hand. I was now determined to concentrate on developing my art. I wanted to contribute something worthwhile to the world's corpus of easel paintings. I felt I had not yet begun to paint.

We found a comfortable place with a southern exposure and a large downstairs room that was ideal for a studio. The house looked out over Semiahmoo Bay towards the Drayton

17 *Detail from* THE POT SELLERS, *lithograph*
From this drawing I attempted an oil painting but got bogged down trying to paint the pots.

18 IN A MEXICAN MARKET
1974
pencil

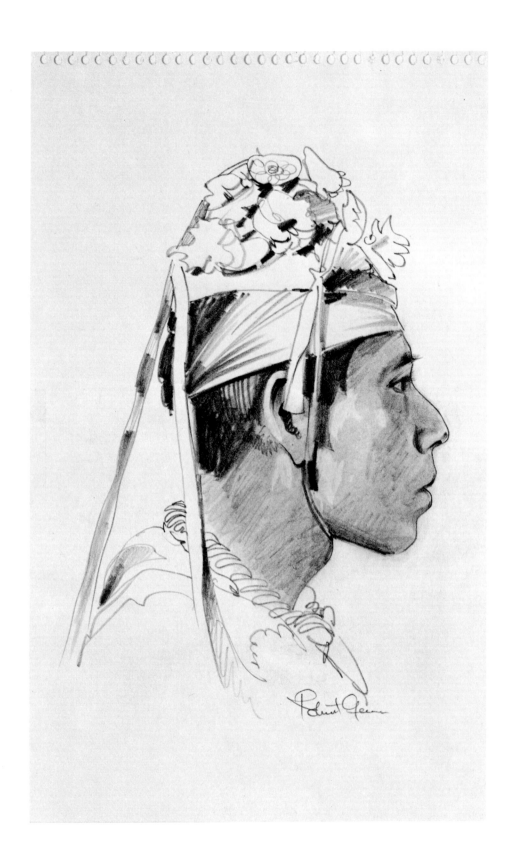

19 VOLODORE, MEXICO
pencil, 10³/₄ × 6³/₄ inches

Peninsula in Washington State. Orcas, one of the American Gulf Islands, was in the offskip. You could see for twenty miles from my downstairs studio. Watching the clouds proceeding toward me from the southwest, I could predict the weather. Here, I could improve my facility with landscapes and incorporate into my work the people, places and scenes that I had collected on my trips. I was able to do large paintings now that I had room to stand back from them and evaluate. I liked to have lots of my paintings around me all the time so that I could view them with detachment and try to determine what was wrong with them and how they could be improved.

We filled our home with my paintings, hallways, bathrooms, staircases, everywhere. There was more than enough room for storage. I began to produce some good work. There were so many compelling subjects to paint at nearby Crescent Beach, at Elgin, and in the Hazelmere valley which was a few minutes' driving time away. I would enter my studio every morning, coffee in hand, review what I had done the previous day and discuss with myself what would be the best thing for me to do that day. Some days what I call my 'metabolism' would let me know what direction I should take. Sometimes it would instruct me to tackle something large and challenging, sometimes it would suggest I rework old themes, and sometimes I would be told to go out and collect new material.

When you love this kind of life, it is easy to keep regular hours. I generally work from nine in the morning until about ten at night, taking short breaks for meals. All days, including Saturdays and Sundays, become like Mondays—work days. Social engagements are worked in and become pleasant respites from the main activity of life.

For a hobby, I started doing something that I call colloids—a combination of collages and discovered objects held together

20 CRESCENT BEACH CRAB
BOAT
pencil, 6¹/₂ × 8¹/₄ inches

with colloidial glue and plaster of Paris. Generally I finished and painted them in white or light colours to integrate them and emphasize their texture. I used the parts of a dismantled camera, a broken pot, the internal pieces of a clock, or other objects that I had picked up in a second-hand store. This seems foolish to a lot of people but I have always been inclined to trust my feelings. If I feel that something is worth doing, then I get on with it as fast as possible in order to get it out of my system and move on to the next stage.

Many styles and techniques are artistic boxes in themselves. But this does not matter because when you work your way through them, you gain the satisfaction of having followed a personal path. Also everything you try is incorporated into your own overall style. This process of experimentation and invention is what keeps your work vital and new.

Lawren Harris said, 'Paintings come out of themselves,' and I believe no truer words have been spoken about the genesis of paintings. Three-quarters of the way through one painting, you are mentally already working on the next one. There is a process, an evolution from one painting to the next. They grow out of each other. Your failures are loveable because they are the keys to your successes. Often a certain subject or technique that will not work in one scale will in another, and you cannot know this until you get started. Artists should take it for granted that getting there is going to be half the effort and half the fun. If you are entirely product-oriented and looking to get your work out into the market quickly, you will never manage to assemble and collect the valuable failures which are the stepping stones to the winners.

It was just a matter of months before my studio became a cluttered mess but somehow out of the confusion and chaos came an ordered succession of good paintings that I was proud of.

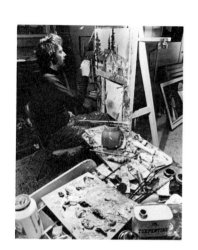

21 *The author in White Rock studio*
photo: Bill Staley

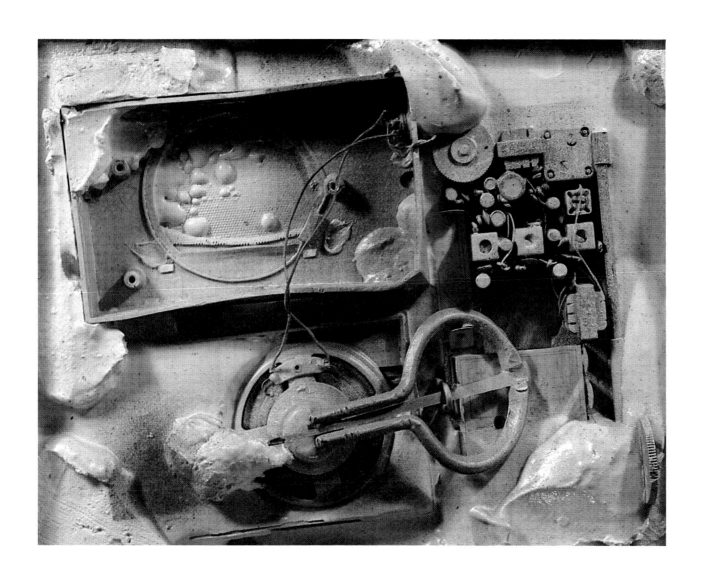

16 SOUNDSCAPE 1971
colloid, 8 × 10 inches

In October 1967, Carol and I thought we would like to see Japan so we flew to Tokyo where we were greeted by our relatives. Carol's family allowed us to get the kind of inside look at life in Japan that is unavailable to tourists. In Japan, artistic sensibilities are a part of everyday existence and they are formed and influenced by a deep awareness of the past. Art is treated as a haven from the perpetually noisy, competitive, over-crowded world. The Japanese popular arts—flower arranging, pottery, weaving, painting, interior design—are concerned with space, gradation, elegance and extended linearity.

There is a real sense of cultural continuity in Japan that is lacking in North America. Carol's ancestors had lived for more than four hundred years in the same ancient towns of Odawara and Nishioi. Her cousins would point out tiny rice paddies that had been owned, and later lost, through numerous generations, during good times and bad. In the corners of their rustic homes was always a small shrine with records neatly labelled on wooden sticks; information about ancestors, where they had lived and what they managed to accomplish in their lives. This bundle of ancestral documentation was held together with a humble elastic band and was brought out for review from time to time.

Masashi San, an uncle of Carol's, had been blind since he was four. We got to know him quite well, and he has visited us in Canada several times since. This man, who goes through life with a perpetual smile on his face, makes his living translating the *Reader's Digest* into Japanese Braille for the one hundred thousand blind people in Japan. He had never seen a white man before and asked at one point if he could 'see' me. I sat close beside him while he ran his fingers over my face.

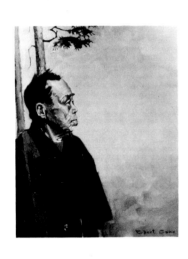

22 MR HANEDA 1967
oil on canvas board
20 × 16 inches

After a few minutes, he asked Carol if I was 'typical.' Yes, she said, very typical. His smile became a grin and then he started to laugh. He could not believe that Carol had married such an amusing looking person.

To Masashi San everything in the world, as 'seen' through the eyes of his wife, is beautiful. He has the advantage of looking at things totally in his imagination, and the world can look however he wants it to. His world is not less real than the seeing one; it has a reality of its own.

It struck me that in art, and in painting in particular, being faithful to objective reality is not particularly important, just as it isn't in Masashi San's life. Paintings should not be what is there to be seen but what is seen, and in that sense, the truth they convey is a more enduring one. To Masashi the world is a beautiful, idealized painting. Sunlight is more intense, grass is greener, and Mt Fuji is more radiant and splendid than to sighted people. Besides, he could always 'see' Fuji whenever he wanted to, whereas we had to wait for a break in the trees.

We traveled south to Kiushu and visited the terror of Hiroshima and Nagasaki. We stayed with friends who took me to a small island called Oshima where people lived much as they had for the last three or four hundred years harvesting from the sea, and growing rice. I found these simple, rustic people fascinating and I painted the fishermen re-stringing their earthenware octopus pots.

I was feeling inclined to do something fresh and quick of a human, figurative nature, and found myself drawn to the Japanese Sumi ink technique. While I do not greatly appreciate the Japanese traditional school, I found the Sumi brush an ideal medium for representational work. During this period I did sketches of my Japanese relatives and friends using the brush. At the time the Japanese devised something that resembled a fountain pen but had a brush at the tip. It was a

23 GIRL AMONGST
CHRYSANTHEMUMS, *Sumi ink
drawing* 8 1/4 × 6 *inches*

proper Sumi brush which you filled with Sumi ink, and you
could produce two or three drawings on one filling. I later
showed this brush to Norman Rockwell and he tried it out in
front of me. He wanted one right away, so I gave him mine.
He wrote me several times asking for more of them. It works
beautifully, if you hold it the right way.

On my return from Japan, I assembled my photographic material and drawings and began to do paintings inspired by Japan. The people on the fish docks at Kobi, women washing dye stuffs in the rivers at Osaka, the temples at Nara, the fishermen at Oshima, and the potters of Nagasaki, made up some of my subject matter. My Japanese paintings emphasize decentralized human subjects with areas of soft space, and gradation in the Japanese fashion.

Back in North America

In January of 1968, we took a slow, loving tour across Canada by car, via Sudbury and ending up in New York and Massachusetts. Upstate New York is beautiful, verdant countryside, studded with houses that appear to be right out of some Gothic novel full of witch trials and ghosts. The rendering of architecture has never appealed to me but these lonely farm houses from the last century with their roof-top cupolas and widow's walks were an exception.

My uncle Jay, who lived in a sleepy hollow called Butler Center near Wolcott in New York, made his living trapping beavers and killing wolves for bounty. We roamed the countryside with Jay, counting pheasants for the Wildlife Department and estimating the deer population of Seneca County. Jay carried a gun and had shot thousands of wolves in his lifetime; he knew everybody in New York State and was a bit of a legend in the area.

He died in 1980 at the age of eighty-six and was buried in Butler Center graveyard, where his father and grandfather are also buried, right behind a large traffic sign on the main street which says, 'Butler Center Slow.' It is difficult to think of any part of New York being slow, but in Butler Center, slow it is.

We visited friends in Pittsfield, Massachusetts, and I did a couple of winter paintings at Tanglewood. Later, I visited

Norman Rockwell in his studio at Stockbridge and persuaded him to answer a few questions that he had left unanswered in his books. Rockwell was glad to meet an enthusiast from Canada. In my opinion he is a star. His paintings are highly refined, sensitive and well-executed yet they are often denigrated by the critics. Rockwell employed a full-time photographer who kept him supplied with black and white eight-by-ten glossies from which he worked.

Back on the west coast, I thought I had better take a closer look at the Canadian Gulf Islands and toured there in spring, summer and fall. Mayne, Saturna, Galiano and Saltspring Island all inspired some work that year. I was bringing paintings home from my trips, putting them around, throwing some out, reworking some, adding to others, and then taking the next big step and revisualizing, sometimes returning to the original photographs.

On the coast of British Columbia, the green of the coniferous trees seems to overwhelm the rest of the scenery because of the lack of space between them. Several members of the Group of Seven had taken a look into British Columbia and decided that the forest was too dominant to be handled effectively. Emily Carr, who was born in British Columbia, studied abroad, and came back to the province, was the only artist of that generation who was able to synthesize a style that maintained the dominance of the trees and captured their aura of mystery. Carr's solution was inspired: a wide-angle forest panorama, low horizons, and forest perspectives featuring struggling trees in lighter colours to draw a contrast to the dark, deep foreboding of the forest. Her super-stylization cannot be imitated; it is her stamp on the spirit of the west coast forest.

On the Gulf Islands, the forestation becomes civilized and less wild with the softening effect of oceanside rocks and

sunny slopes. Here there is a peace and a tranquility near the wall of green.

Early Family Years

On March 2, 1969, our first son, David Robert Madison Genn was born. Hombre, our poodle, gathered up his bones and threatened to leave home. He had been getting all of the attention until now. I am afraid that up until this time, I also had a negative attitude toward children. I considered breeding a rather prosaic form of achieving immortality. Of course, artists can live on for a long time through their work, but when two people get together to produce another human being they are assured of big-time immortality. We lay awake listening to him breathe and flashed on the light the minute he seemed to stop. But he was a healthy baby and, from his first potato-like beginnings, was the subject of many drawings and paintings.

At this point, I had made a switch to acrylics for the main reason that I wanted to cover up underpainted areas that were not quite to my liking without sullying the overpaint. If you are an impatient artist, acrylics are a good way to go. They are virtually impossible to work with outside in sunny weather, but in the studio, with a small amount of drying retarder, they work fine.

You really have to work hard to establish any sort of a texture with acrylics. It comes easily in oil which has a rich, buttery nature. But the fineness of acrylics enables you to do anything from broad, impressionistic brush strokes to fine line watercolour-like works. There is a tendency, as the painting develops, to proceed into small and smaller brushes, often to the point where the detail takes over.

For many years, I had dealt with the trap of slipping into 'illustration.' At the Art Center School I had found out that

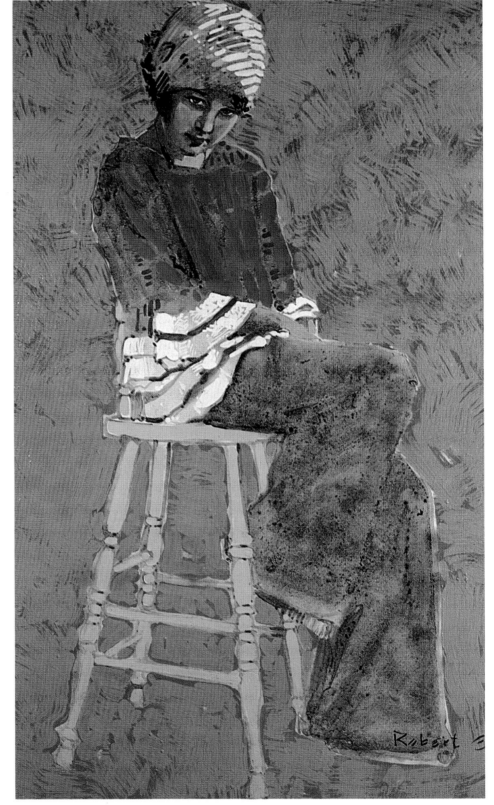

17 *Detail from*
PORTRAIT OF JHAN FORD 1974
acrylic on panel, 30 × 24 inches
A teenage subject done
in two sittings. The colour remains
crisp and bright, like the model.

my strength lay in my drawing and, time and time again, I would use it to solve all my technical problems. It was the line of least resistance for me and I availed myself of it repeatedly. The result was a lot of mediocre paintings. There is no single secret for the production of good paintings, but I am certain that it is necessary to learn to keep certain things in mind. A golfer must learn to keep his head down automatically while addressing the ball because only then, when his stance and posture are under control, can he concentrate on his swing. In painting it is important not to allow any single skill or technique to predominate. There were a few complicated and involved acrylic paintings done during this period, many of my son David, when I lost control. The results were well drawn but generally weak in pattern and composition.

It was at this time that I rediscovered the need to do roughs. I had tried to put roughs out of my mind since the Art Center days when I had over-dosed on them. But now, when complex, larger works are about to be begun, I spend considerable time on the preparation of preliminary sketches. All of the elements are assembled, either in the form of photos or drawings, and the format is developed—that is the proportions of the edges of the proposed canvas. Size is determined later and depends on the scale required to render faces, hands, etc. effectively. I do a sketch in black and white rather than colour, in order to establish light and dark. Pattern is crucial at this point when the potentially dark areas are being filled in. Activity is added to lead the eye around the painting through a system of dots, spots and lines. An arrow is put in, indicating the direction of light. When a rough drawing proves unsatisfactory, a new solution is arrived at and a new rough is attempted. Better to make the mistakes in the rough than to discover three days later, when you have a finished painting on your hands, that the composition is poor.

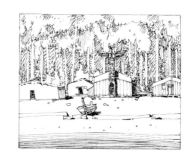

24-29 Rapidograph pen
thumbnail sketches.
I wonder how many paintings
a person could do?

30 CHILDREN OF
KITWANCOOL 1971
lithograph, 13 × 20 *inches*

In July, we decided to drive as far as we could across the northern Prairies. David, in his crib, fit nicely in the back seat of the Jaguar. The unpaved, unsophisticated, and unassuming towns of northern Alberta and Saskatchewan are statements of hard-working honesty to me, and there is that omnipresent cliché of the Prairie landscape, the grain elevator. In the tiny village of Tiny, Saskatchewan, we sat in the shade of a red elevator while I performed on a small panel. The manager of the elevator asked me where I was from, and when I told him British Columbia he suggested that I might not know how a grain elevator works. I agreed since I had never investigated the internal mysteries of one. He proceeded to give me a tour, and I was surprised to find a complex network of chutes, bins, straining apparatus and an ancient engine that made it all work. The knowledge of the anatomy of a subject is not essential when you are painting the external aspect but it helps by

increasing your respect for your subject matter and by giving you the little bit of extra staying power that enables you to finish the work. I decided to make the Tiny grain elevator my headquarters for a day. I painted it from all sides in different kinds of light. Later that week, I put Ukrainian Orthodox churches under the same kind of artistic scrutiny.

Returning from our examination of the dusty northern Prairies, we flew to Bradbourne, Derbyshire, to be with our friends the Wallises who were anxious to meet David. At the villages of Fenny Bentley, Tissington, and Brassington, all within five minutes of Bradbourne, I did some small paintings. We passed through Leek in Staffordshire, and there I purchased a 1937 Bentley. To this day, this car looks like a magnificent, land-locked yacht to me. Designed and built at the apex of British automobile design, it is rakish and knife-edged, with great Lucas headlamps and side-mounted tires.

The next week, we all flew to Dublin, rented a Commer camper and headed west across Eire. The Irish are very friendly and in the pensions and small hotels they would always find an extra crib for our child. They also did not object to keeping an eye on your baby while you were down at the 'Singing Pub,' drinking Guinness draft and marveling at the ubiquity of Irish tenors. The countryside has at least forty different shades of green in it, and the skies are constantly changing, opening and closing, presenting you with new vistas every few minutes.

In southern Ireland there are tremendous learning opportunities for an artist. The distant hills recede in shades of greys, blues, and purples, and the foregrounds dazzle you with emerald greens interspersed with rocks and sparkling rills. Weathered characters cut peat or dig potatoes in the fields, and black-haired, rosy-cheeked colleens run laughingly down the lanes between the rock walls.

Back in Canada, I was loaded with photographic material

31 *Detail from* PETER AND DOGS—SKEENA CROSSING, *lithograph*

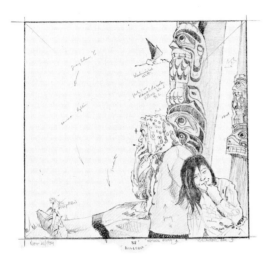

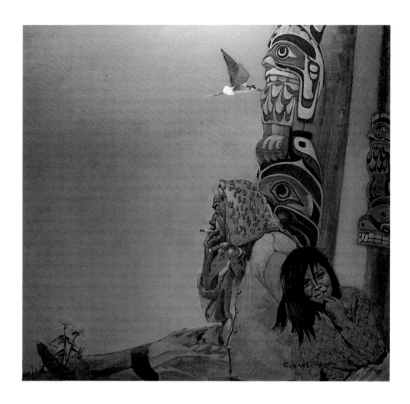

from the trips to northern Canada and the British Isles. I had
learned by this time that large amounts of reference material
would ensure a happy productive fall and winter in the studio.
A few minutes at my light table with recent slides would
indicate the direction of the day's work. One thing I have
learned is that it is not a good idea to enter the studio feeling
obliged to fill specific orders or produce certain varieties of
painting. I go to my imagination, my reference material or to
half-finished paintings and let the ideas circulate in my mind
for a few minutes. A simple equation for the production of
successful art work is lots of reference material plus lots of art
supplies equals lots of painting happiness.

By January, we had itchy feet again and decided to drive south
towards the Taos/Santa Fe area in New Mexico. I had never
seen this area in winter and thought it might make a nice
contrast to our previous trips. On the way, we passed through

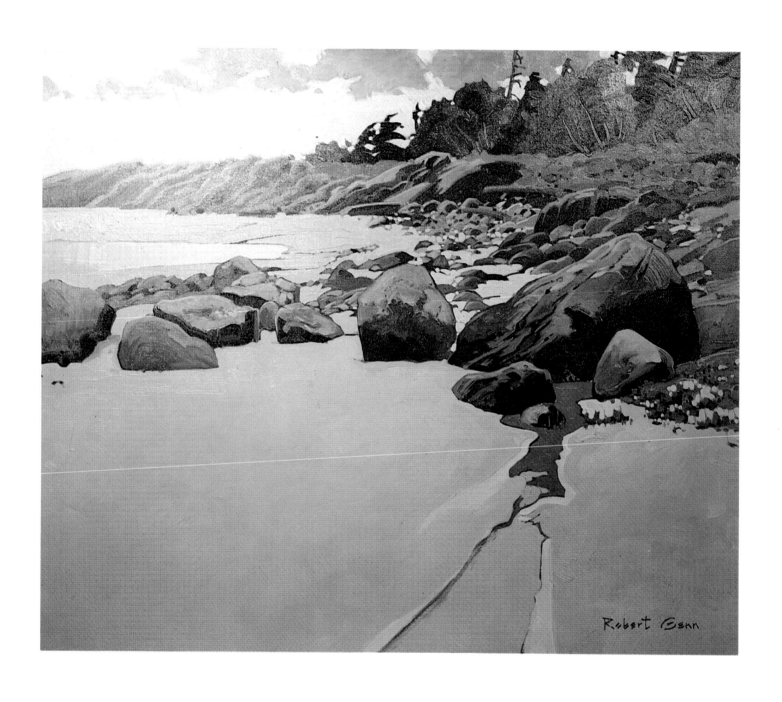

19 BEACH, CALVERT ISLAND 1980
oil on canvas, 30 × 36 inches

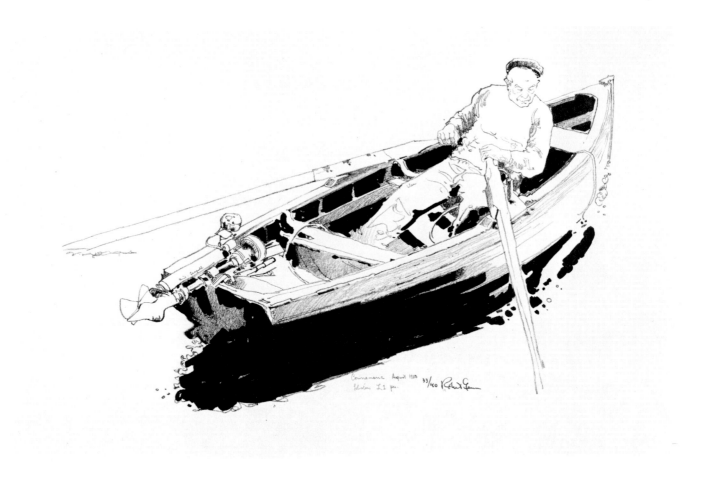

Virginia City near Reno in Nevada. This historic mining town with its false store fronts and the mansions of the fortunate provided some good subjects. In Taos there are many galleries, and one frequently sees evidence of the great Taos artists of the twenties and thirties. I had always admired the Taos Ten, a design-influenced group of southwestern artists, who are as much a legend in their country as the Group of Seven are in Canada. Up to this time, I had always been quite promiscuous in the selection of my tubes of colour, but seeing the palettes of some of the Taos artists sparked a change that continued for several years. I switched to a very limited palette which consisted of cadmium yellow, cadmium orange, cad-

mium red, alizarin crimson, ultramarine blue, and white. On occasion I would add thalo green or raw umber, and on very rare occasions I would add black. It is amazing the subtle variety available when using a limited palette. The predominant feeling of these colours is one of warmth, and if you mix well, this unifies and neutralizes whatever you paint. The colours must be prepared in advance. Premixing and neutralizing are time-consuming. It is really not possible, unless you favour colour surprises, to use the paint directly from the tube.

There is a strong tendency to complicate work habits in the belief that by adding new steps and procedures you will end up with a better product. I believe that it is important to force yourself to simplify. I am always trying to re-design a smaller more compact, simpler, traveling paint box. The ultimate box, one that would fit into my pocket, has not yet been developed, but some day I hope it will. A heavy box with inertia is useful too, but I have never really settled on any particular model. I generally build one myself and use it until I get tired of it. The only advice I can offer on this matter is that if it feels good to you, use it until you find something that feels better.

Whenever I have given demonstrations, other artists are inclined to ask what sort of blue I use or what kinds of brushes I prefer. No doubt all artists are deluged with these kinds of questions. I always make an effort to explain that it really does not matter whether you use cobalt blue, cerulean blue, or ultramarine blue. Mixed correctly with the right amount of whites, yellows, or crimsons, almost any atmospheric effect or aerial perspective can be created with practically any of them.

Recently a friend of mine who is not a painter came along with me to a seminar where about one hundred enthusiastic

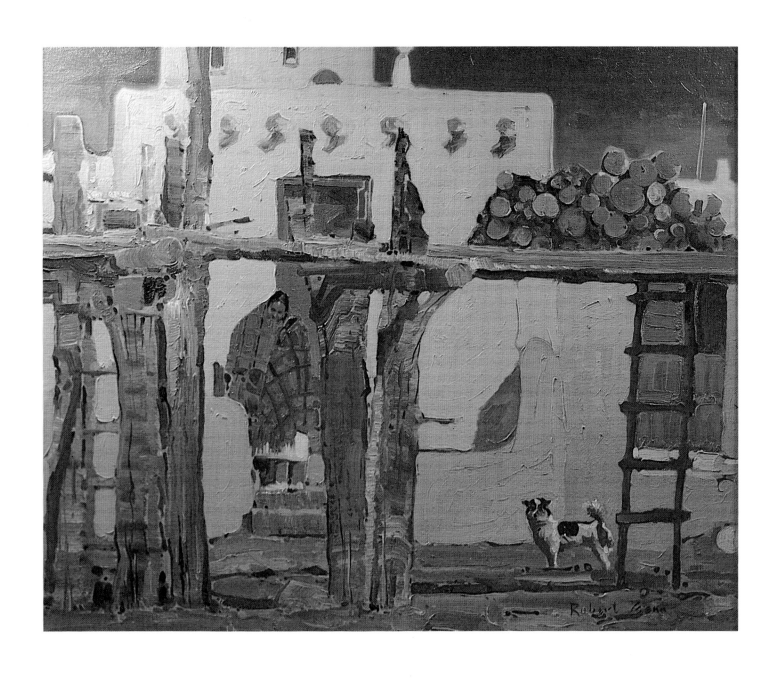

20 AT TAOS PUEBLO 1971
oil on canvas board, 20 × 24 inches

amateurs interrogated me for two hours as to which this and what that to use to achieve what effect. After the lecture, on the way home in the car, my friend made a remark that I found particularly apt. 'They are all looking for the secret, and the secret is that there is no secret.'

At Acoma Pueblo in New Mexico and in the Hopi and Navajo nations, I applied what I had been able to glean from studying the paintings of the Taos Ten. One of the artists whose work appeals to me most was Nicolai Fechin. Fechin painted portraits of native people who were most often neutral in expression, that were restrained, straightforward and glorious in their simplicity. The centre of interest, hands and faces, was well delineated in a fresh, direct manner. Fechin's backgrounds, which in time became increasingly impressionistic, were painted with a bravura of colour and texture. His taste was impeccable, and his works have maintained their quality over the years.

The southwest, as subject matter, held my interest for a long time. It was a rather good period in my career. I guess it is safe to say that it was a 'period,' although at the time I was unaware of it being anything of the sort. I wonder if Picasso knew when he was entering his 'Blue Period.' An artist may be interspersing one style with another on alternate days, so it is difficult for him to identify periods as they occur. At an exhibition of my work in Montreal a few years back, a man approached and said, 'Mr Genn I have a work from each of your fourteen periods.' I would have been unable to identify even one of what he called 'periods,' let alone fourteen!

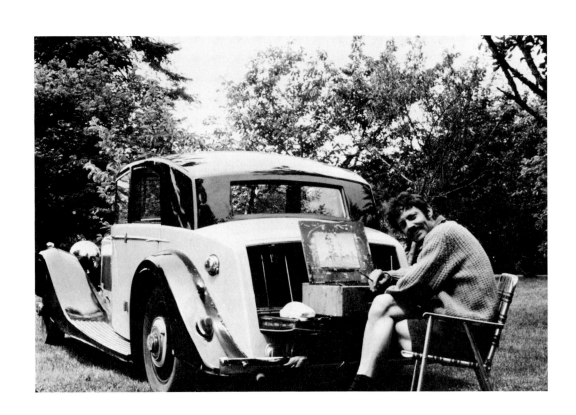

34 *The author painting at the back of the Bentley*

NEW SUBJECTS AND STYLES

In April of 1970, the Bentley arrived in Vancouver by ship. I stood on the Lion's Gate Bridge and celebrated the event as the freighter passed right underneath me. Eagerly arriving at the Customs' shed, I was informed that I could not have my car until it underwent an inspection by the Department of Agriculture. 'But,' I said, 'the car has been fully restored in England. It is perfectly clean.' The agent took me over and showed me great clods of cow manure and other unsavoury matter affixed to the underside of the fenders. The guy who sold it to me must have driven it around in the fields while making the final arrangements for the shipping. After three days of heated negotiation and a thorough steam cleaning, I had my car and drove happily home to White Rock. The Bentley has a double-folding trunk, or 'boot' as the English call it, that is a marvel. It is the perfect place to keep my sketch box on journeys. It gave me a great feeling to go out to interesting locations in that car and do sketches. The only problem with it was that it tended to attract attention, and attracting attention is something I usually try very hard not to do. I used to be very poor at handling people who watched me while I worked but lately, particularly since the advent of the Bentley, I have become less concerned with observers. Once as I sat painting, I became aware of a man's face hovering near me, moving closer and closer to the panel that I was working on. When he spoke he said, 'That is a fantastic brush!' Judging

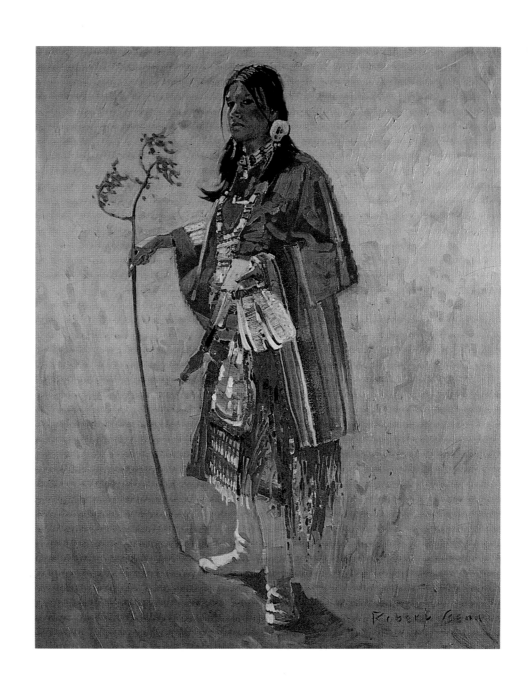

21 NAVAJO GIRL, GALLUP 1972
acrylic on hard board, 30 × 24 inches

from the note of amazement in his voice I would say that he believed it was the brush that was responsible for the painting.

By summer I was running out of material from the trip to the southwest the previous winter, so in August I took my first trip to Gallup, New Mexico, for the Inter-Tribal Indian Ceremonials which are held there every year. The Ceremonials are a gathering of Indians, perhaps fifty thousand of them, from all tribes and bands in North America, including Mexico and Canada. In the old days, they came by travois and covered wagon; nowadays they appear in pickup trucks and Cadillacs. Every type of ceremonial regalia can be seen in a few square miles for a few days each August. The event attracts photographers and cinematographers from all over the world. The first day, in the photographers' compound I was flanked by Walt Disney productions on one side, and a Swiss filmmaking team shooting an anthropological documentary on the other. Professional photographers are forever asking Indian chiefs to stand on rocks and look intently out over the horizon while shading their eyes with their hand. Unfortunately for the photographers, the city and environs of Gallup, a very American town, somewhat destroyed the mood they were attempting to capture on film. Painters do not have this problem. They can simply leave out any undesirable elements in the scenery so telephone wires and TV aerials never pose a problem. We also have the time to labour over our work to eliminate any clichés. Painting is at the same time an opportunity to idealize, and an invitation to avoid the truth. In my experience, it is the times when it is possible to accept the reality of a scene that is being painted that produce the best work. On the West Coast once, I painted a decaying totem pole that had a clothesline festooned with clothing attached to it. I felt it was an accurate portrayal of the times we live in.

22 Southwest material with less than the whole subject in evidence oil on canvas board, 1970 18 × 24 inches

35 Sketch, Gallup 1970 pencil, 10³⁄4 × 7 inches

In the afternoon in Gallup, after a hot day in the photographers' compound, I was checking into my hotel room when I noticed a particularly beautiful young Navajo girl of about fourteen years of age. I struck up a conversation with her and asked her if she would pose for a drawing. She agreed and said that it would cost me two dollars. She came to my room and sat demurely on the edge of the bed while I sketched her. After I had completed the drawing she said, 'You should see my mother.' I waited for a short while and then in came a remarkably poised Indian lady of thirty-five. For the sum of two dollars I sketched her as well. She suggested that I might be interested in *her* mother and disappeared returning shortly with the most magnificently weathered and elegant Indian woman I have ever seen. This beautiful matriarch also agreed to pose for me for two dollars and I did a drawing of her. When I had finished I asked her to pose for three more sketches at two dollars each, and from those sketches many paintings were later developed. She wanted to buy the drawing of her granddaughter. She offered me two dollars but I gave it to her free of charge.

There is a real problem in doing sketches of people for later use. If the drawing turns out well, particularly if it is a good likeness, somebody in the family invariably wants to buy it from you. For several years, I had been experimenting with a method of making lithographic drawings. The drawing was done on a lithographic master which I could take home and make copies from to give to the people who posed for me and still have some left to work from. The trip to Gallup was the last time I gave drawings away to people without having a copy for myself.

In January, Carol and I left for an extensive tour of Mexico. After a week in the museums and galleries of Mexico City, we retraced the route of Hernando Cortez, traveling east where the 185 Spanish Conquistadores had come on horseback. We

visited Villahermosa, Merida, and Chichen Itza in the Yucatan and eventually arrived in Isla Mujeres on the southern tip. This lovely island was an early outpost of the Aztec Empire and remnants of shrines and temples still exist there. We rented motor scooters and inspected the place thoroughly. Islands in particular have always fascinated me; I like their completeness. I try to learn as much as I can about the flora and fauna, the history and the people while I am there. Giant sea turtles swam in the lagoons at Isla Mujeres and were regularly consumed by the locals. We had one meal of sea turtle which tasted and looked very much like beefsteak. I decided they were far too noble, ancient and beautiful to take for food, so I painted one. It was a form of penance.

Satisfied that we knew Isla Mujeres inside-out, we returned across the Yucatan to Oaxaca in southern Mexico. This city with its ancient churches and Aztec shrines is surrounded by small villages, each with its own distinctive local crafts. Workers can be seen in the sun, weaving, doing wax and string work, beading, pottery, and bark painting. The markets were full of activity, colourful costumes, children, livestock, swine, fowl, fish and fruit. In busy locations like this, with people as my intended subject matter, I use a 135mm medium telephoto lens. When we were living in Spain, we had briefly been to North Africa and I had found this lens ideal. Finding subjects and asking them to pose does not appeal to me as much as simply stealing the shot. With the 135mm lens, people usually remain unaware that they are being photographed and are more natural, going about their usual business while you snap away. In more sophisticated areas, I have used a small right-angle mirror on the end of the lens which permits me to look, with the camera in one direction and take pictures in another. This method takes a bit of getting used to and is not as good as keeping your eye in the viewfinder and taking pictures while moving around.

36 TURTLE POOL, ISLA MUJERES
oil on canvas, 24 × 30 inches

Another effective way of doing it is to use a wide-angle lens, such as a 35mm or even 28mm, set it at a relatively fast speed and move close to the subject with the camera hanging near your waist. You can fire off quite a few photographs without anyone noticing. The only problem is the distortion and pin-cushioning effect you get with a wide-angle lens. One Mexican artist we saw utilized the 'fish eye' effect of the wide-angle lens and painted directly from his photographs with interesting results.

One day soon, they will be bringing out a new zoom lens that runs between 35mm and 200mm. This will be the perfect artist's lens, for it will provide enough wide angles to permit interesting compositions with eye lead-in and perspective, and will be equally handy for portrait and character shots taken from a distance.

In February, I had an exhibition in Calgary, and during the drive there made further use of the 135mm lens. The semi-telephoto aspect is very effective when combined with mountains, clouds and distant landscapes. It draws your attention to the two-dimensionality of subjects, screens out unnecessary subject matter, and multiplies the images that you can capture from a single location. There is no such thing as a ready-made painting to be found in a photograph. Something always has to be changed. I am sorry to say that from an artistic point of view, God's compositions are not always up to scratch.

At Two Jack Lake near Banff, I parked the car and put on my snowshoes. The lake was frozen over and the snow on it was very deep. Carrying my large paint box, I decided to head along the shore towards the south west. Rounding a point of land, I saw ahead of me a pack of wolves, and noticing that several of them were very large, stopped dead in my tracks. They stood, watching me from a distance of about a quarter of a mile. Eventually they started to move out onto the lake

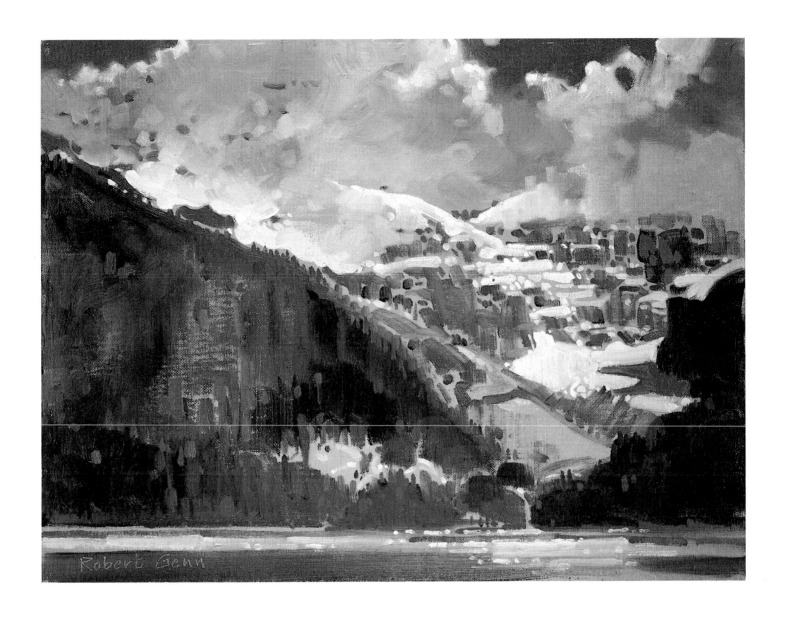

23 *Sketch for* GLACIER 1973
12 × 16 *inches,*
done after the fact utilizing medium telephoto effect

toward me, moving slowly in the deep snow. 'This is it,' I thought. Headlines flashed before my eyes: ARTIST EATEN BY WOLVES ON TWO JACK LAKE. I turned around and followed my tracks back toward the car a half mile off. When I moved the wolves stopped, some of them even sat down. Each step was bringing me closer to safety but the snow was retarding my progress. It required a tremendous effort just to lift each foot and put it down. My heart was pounding but scared as I was, I never thought of leaving my paint box behind. I tried to move confidently, nonchalantly, like I had done with vicious dogs when working for the *Saanich Star*. I wished that I were back in Saanich. I didn't allow myself to look back for long periods of time. After what seemed like hours, the car came into sight. With my last ounce of energy I heaved myself over the bank, climbed into the car and turned the heater on full blast. I sat there for half an hour until I stopped shaking. So much for intrepid forays in the wilderness. I would confine my artistic wanderings to safer areas in future.

At Banff, Canmore, and Bragg Creek, in temperatures far too low for me to work comfortably, I photographed the ice and snow lodged in delicate patterns between the branches of the trees. When projecting these slides later on, I discovered that in order to make a good painting out of the scene, shifts left or right were necessary between the trees, the curves needed to be emphasized, and ugly areas redesigned. For the necessity of achieving an effective pattern in paintings, I have a method that works quite well. When selecting subject matter from slides, throw your projection lens out of focus to the point where the contents of the shot are unintelligible. Study the relative darkness and lightness. It is easier to see what you have to do in order to make the total composition more effective.

Returning from Calgary in a blinding snow storm, I

stopped at fellow artist Jack Hambleton's home at Kelowna. Lorna, his wife, thought I had better have some sustenance to keep me going along the way. She gave me a bag of the largest and hardest home-made cookies I had ever encountered. I tried to eat them as I drove along but since they were not one of Lorna's baking triumphs I decided to try them out as painting panels. I had never worked on a cookie before, nor on a round panel, but it took the paint well with a minimum of priming. I amused myself by doing several of them. Later, I gave the best one to Jack and Lorna, and they had it framed in a nice round frame. To this day it hangs in their kitchen and is quite a conversation piece. Over the years some bugs have also begun to enjoy the painting in their own way.

I painted on many strange surfaces in the early days, mostly out of poverty. Lately I have been able to subsidize my penchant for expensive cigars by painting on the mahogany boxes my favourite brand of Cubans comes in. A couple of years ago, I did a painting of a 1935 Bentley on a portion of the original convertible roof canvas. It was a suitable memento for the owner of the car who was having it fully restored.

By now Carol and I had developed the habit of leaving and traveling by car throughout British Columbia and Alberta, both with and without David. The Skeena valley can be reached by car in two days and I did paintings in Moricetown and Hazelton and Usk. In the summer, I took a second trip to Gallup, New Mexico, for more Indian material. That same summer, we traveled by car to Banff, Revelstoke, and Golden and spent several days in the Quilchena Hotel near Merritt, one of my favourite spots in British Columbia.

Good material abounds at Quilchena, around Nicola Lake, with its A.Y. Jackson-like rolling hills. At Quilchena, I painted an eight-by-ten while mounted on a horse. The horse was very patient but the mosquitoes were not, and when I

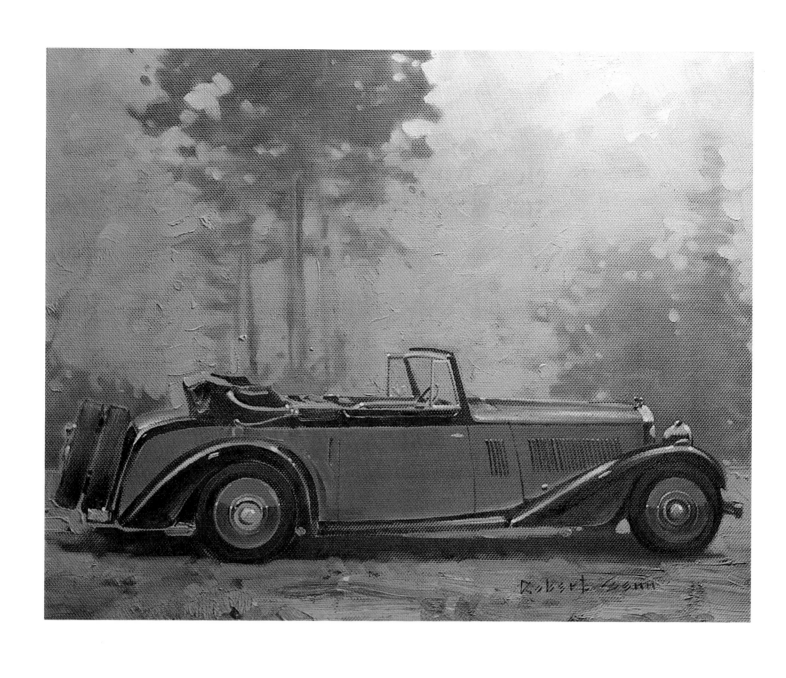

24 1935 BENTLEY 1975
painted on its original roof canvas, 16 × 20 inches

was finished, I found that my ankles were so bitten they were just about ready to let go of my feet. It was a great test of endurance and concentration.

I heard A.Y. Jackson say on the radio one day that he felt that every artist had a maximum of twenty-five hundred paintings in him. I was well past this figure already and I began to get worried, but when I thought about it I realized that this is not always the case. I had noticed a kind of senility in the later work of Jackson and also Lismer, but artists like Casson continue to refine and improve their technique well into old age. This growth potential is one of the things that has always appealed to me about being a painter. There are always new things to learn and different techniques and styles to try. Opera singers, ballet dancers, and athletes are often finished by the time they hit middle age. But painters can go on practically indefinitely if they can keep themselves together physically. On the last day of his life, Picasso proposed a toast to the greatest artist the world has ever known, himself of course, got up from the dinner table and proceeded to his studio where he worked until four in the morning. He died at the phenomenal age of ninety-one with his brushes still wet. That is the way to go!

Avoiding artistic senility may be just a matter of good luck. Some artists have the good fortune to be able to hang on to their technique and creativity right up until the end. I have noticed that certain young artists, artists even in their twenties, suffer from premature senility. Their work looks vague and repetitious, the brushwork tired and bored. They were not observing things properly. Maybe this is the key to it. Each new work must be looked at with new eyes and assessed accurately for what it is. Furthermore, artists should vary their subject matter and style in order to gain perspective on their work. A two-day rest doing pencil drawings or watercolours is an effective respite once in awhile and can result in renewed

vigour. To maintain a fresh approach throughout your painting life, I believe you must handle the job like an inventor, exploring all new avenues as they present themselves, and never repeating an experiment exactly.

I have always found togetherness among artists to be counterproductive. Artists who spend a lot of time in each other's company have a tendency to commiserate and wallow in their mutual problems, rather than helping one another to overcome professional obstacles. The jealousy of other artists can be a destructive force. It is a complex maze that only a staunch individualist can find his way through.

We live in a society that is increasingly mechanized and where professional specialization has become the order of the day. Painting is one of the few remaining occupations where you can pick up the ball, run the full length of the field and score or not score, all on your own. A painter has to accept the fact that some things he does are going to be good and others are not. There is no point in pretending that our failures are successes, and don't try to explain them, just accept them.

Whenever I felt the need, I would share my painterly troubles with fellow artist Egbert Oudendag who lived nearby in White Rock. He is what you would call an 'old pro.' A unique and independent thinker, stubborn in all the good ways, he is the closest you can come these days to a 'pure artist' (in the Van Goghian sense). Egbert and I would discuss many things intensely and we were usually in complete agreement with one another. With his enthusiasm, wisdom and intellectual integrity, Egbert inspired in me the resolve to stick with my chosen direction. We understood each other, but we remained two solitudes.

One day, when I was particularly low, I found my way to the doorstep of Egbert's studio. I could hear him moving about inside. After a long while he opened the door a crack and regarded me intently. 'Bert,' I said, 'I am in trouble. I can't

draw these days, my colours have gone bad. I just can't seem to do it anymore.'

He didn't invite me in, he just stood there scrutinizing me, pitiful creature that I was. 'Robert,' he said finally, 'you are an ass.' He shut the door and I went away, as usual, in complete agreement with him. My work improved that same day.

Later that month I flew to Kleinburg, Ontario, to take a look at the McMichael Collection. I wanted to try and see if I could understand some of the well-springs of the Group of Seven. I had studied everything I could about these great Canadian painters who most people think were a closely knit group of mutual supporters. In the beginning, they fought the establishment with art no one understood. They were, in fact, all confirmed individualists who joined forces for a very short period of time for selfish reasons. Some of them did not communicate with one another for decades after they disbanded. The general quality at Kleinburg is excellent, and it is one of the few establishments in Canada where I feel a tug of national pride. The palettes of many of the artists are displayed and these were particularly exciting to me. On two or three of them, I found a large blob of neutral but coolish medium grey, far lighter than Payne's Grey but definitely right out of a tube. It looked like the Davey's Grey that I was used to in watercolour but was unable to find in oil. I discovered that Davey's Grey was discontinued some years ago and that one of the various warm or cool Illustrator's Greys were now being offered in its place. This is an excellent colour to use, and you can see it throughout the work of the Group of Seven. It is a weak tinter and combines well with other colour mixtures, particularly greens and crimsons. While it is always nice to mix your greys yourself, having this one in copious quantities, ready mixed, is very handy and speeds up the operation. With regard to the palettes on display at Kleinburg, it is not likely that any member of the Group of Seven stayed with

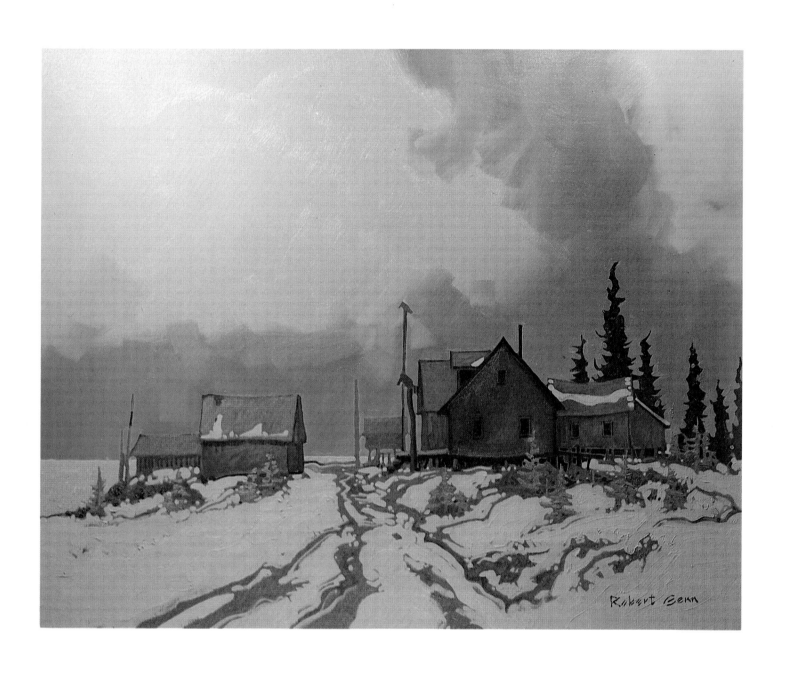

25 WEST COAST VILLAGE (*and the Kleinburg influence*), 1980
oil on canvas, 24 × 30 inches

one of these palettes for an entire lifetime.

Back at home, I began working with renewed fervour and gusto. My tank had been topped up by this visit to Kleinburg. There is no question that seeing good art can stimulate a painter to produce good work himself. Some artists never bother looking at the real world at all but go from gallery to gallery, picking up new ideas. This seems to me to be a bit one-sided. There is a happy balance to be struck between deriving inspiration from other artists and getting ideas from personal observation of reality.

Toward the end of May, 1972, I took Carol, who was pregnant for the second time, into the Peace Arch Hospital in White Rock. The doctor had been hearing what he thought was a heart murmur and on May 25, we were amazed to find out that we had twins on the way. On May 27, James Douglas Hawke Genn and Sarah Jennifer Genn were born. There was great excitement around our house. Hombre the poodle was predictably disgusted and had to spend three weeks with grandma and grandpa in Victoria. I telephoned everybody that I knew and told them what I had done. I had thought that twins were only possible when a fellow was a football player or a super-athlete of some sort. I was a bit deflated to learn that it was only a matter of odds, a roll of the dice, a chance of one in seventy. Twins are truly a revelation to a parent. Having children one at a time seems terribly pedestrian to us now.

During this period, I had been a frequent observer at the local ballet school which was run by a Miss Margaret Perry. I had in mind that I might assemble a collection of paintings *à la Degas* of young ladies on point reflected in mirrors, and of the general milieu of the school. For several months I hung around, taking photographs and doing drawings. I was concentrating on four girls from two families: Beth and Jhan

37 *Little ballerinas at Margaret Perry's School, White Rock* 1972, *pencil*

Ford, aged nine and eleven; and Deirdre and Lisanne Arlt, aged nine and eleven. One day Margaret Perry, who was concerned about my omnipresence, asked me just exactly what I wanted. I told her I would like a day to pose the girls as I wished in order to compose scenarios and tableaus with the appropriate props. After I had completed my *mise-en-scène* I would take as many photographs as time would allow. She decided that this could be worked into a legitimate exercise and I was granted a day.

I filled several cameras with film, set up stepladders so that I could get high angle shots, and arranged everything in preparation for the arrival of the girls later in the afternoon. The place was full of antique furniture, old clocks, racks of ballet costumes, ornate mirrors, Tiffany lamps, combs, brushes, and other paraphernalia. The girls entered and got into their tutus and tights and I ran them through a series of combinations that would have kept a smile on Degas's face for weeks. I tore up and down ladders, snapping away crazily. It was a photographer's dream.

The result of this exercise was an extensive exhibition of about seventy paintings a few months later. I loved watching the expressions on people's faces as they entered the gallery, expecting trees and rocks, like my last show, and seeing a collection of neo-impressionistic little girls in ballet costumes. Even the dealer was perplexed.

This job being done, I was tired of people-painting for a while and hungered for some serene landscape work. I had a station-wagon that I could sleep in at this time and with five pounds of granola and a couple of bottles of antipasto, I proceeded north from Squamish on Howe Sound towards Lillooet. In the mornings, I was able to awaken immediately on top of potential paintings. The early sun illuminated the fireweed from behind making it seem as if it were indeed on fire, while mountain freshets ran through the burn among the mossy bundles at your feet. Subject matter was everywhere – the creeping dogwoods below, the distant mountains beyond. Only the need to keep moving on propels you down the road at noon. Could it be possible to cover the whole world in this way? At Bralorne, in a deserted gold mine, I found men sifting through the sand that had fallen through the floorboards of the old mill, looking for bits of the precious metal. The old pits and the mine building itself were beautiful beyond

38 PORTRAIT OF BETH FORD, *one of the girls from the ballet school* 1972, *oil on canvas,* 30 × 24 *inches*

description. I couldn't help comparing myself to those miners searching for gold.

Artists have to contend with the fact that painting is a solitary occupation. When would-be painters ask me what it takes to succeed I often ask them how long they can stand being alone with themselves. Even after years of painting, the loneliness and the feeling of isolation can become overpowering and begin to interfere seriously with your work. This is the painful part of being a painter, but it is compensated for by the deep satisfaction that comes from having produced a really good piece.

The close proximity of wife and family counteracts the feeling of isolation and adds to the general feeling of personal satisfaction. My paintings can travel around the world by various means of transport and, in this way, I can share my experiences, my feelings, and my ideas with collectors of my work. Even with all of this, I do not want to give the impression that there is anything superior or precious about an artist or what an artist does.

It is important that artists surround themselves with things that will allow them to get into a creative state of mind. Creativity can flourish in some kinds of company and not in others. I took a trip to northwest Washington State with my boy David and found him an excellent companion in all respects. He is a good little traveler, wandering off on his own to the water's edge collecting shells and watching the crab world in the intertidal. In short, he got into his own space. There was snow on the beaches and on the logs at Neah Bay and also hundreds of thousands of visalia that had been washed up by a recent storm. David played quite contentedly for more than two hours without coming back. I noticed him standing in one position for fifteen minutes, watching the eternal roll of the sea.

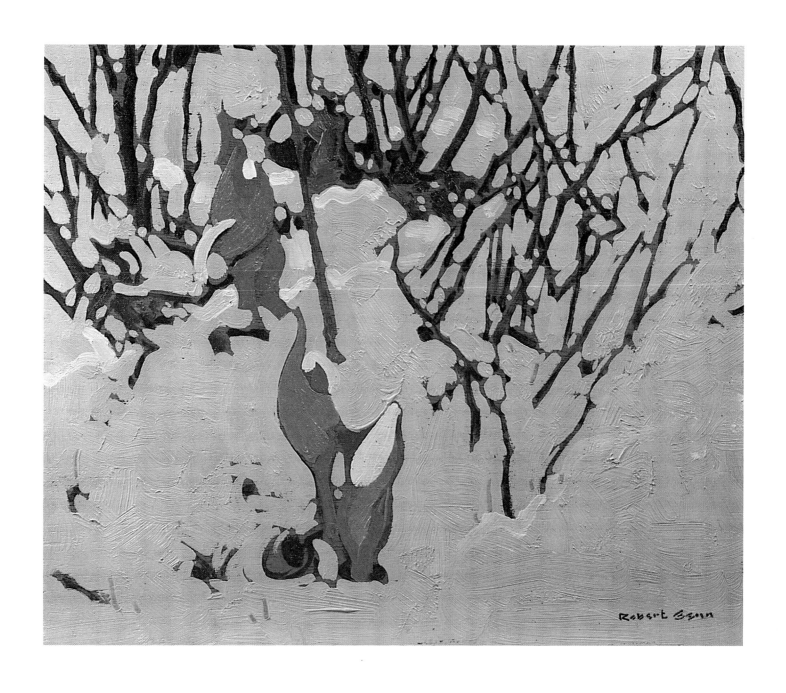

26 MARCH SKUNKS 1981
oil on panel, 10 × 12 *inches*

·93·

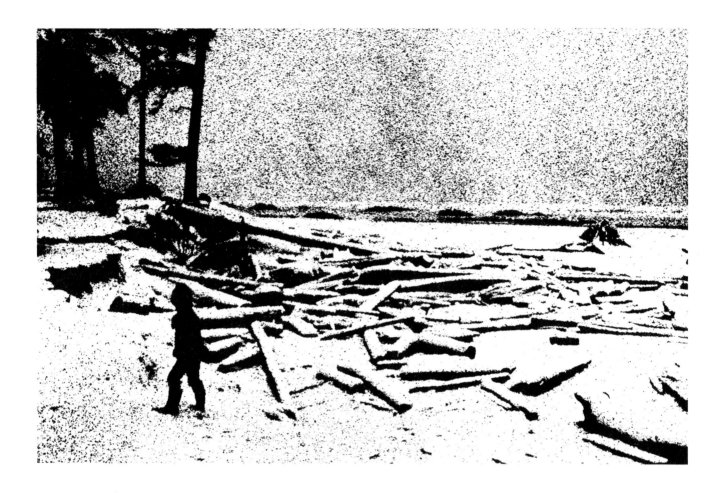

At Cape Flattery, I painted some skunk cabbages thrusting their way up through the remnants of winter snow. I called the painting 'March Skunks' and later did several variations. Skunk cabbages, despite their musty odour, are a popular harbinger of spring in our area. The theme of these paintings—rebirth and renewal—is a frequent one in my work. The subjects are expressed with love, one at a time and in repetition, like the seasons.

In August I flew to the Queen Charlotte Islands with Bill Staley, the photographer. Bill and I work well together. I like to say we have compatible metabolisms. He is no faster or slower than I am, and he does not feel the need to say a great deal, but when he does it is worthwhile. I have a tendency to

39 *David played on the beach for several hours while I worked*
photo: the author

gab along a bit, being one of those people who seldom know what they think until they hear themselves say it. Bill did not seem to mind listening but still reserved most of his enthusiasm for the environment. His eyes are different from mine and he picks up things I miss. The car will sometimes come to an abrupt halt when he sees something that I do not. Without speaking, he will get out of the car, move into a field and take a picture.

I have always insisted on using my photographs from which to do paintings. This would make me feel that the subject was totally mine. But seeing and experiencing through another pair of eyes can be enlightening. Sometimes photos can be evaluated by the photographer with a sufficient amount of detachment, no longer being concerned with the effort made getting them. The distance you travel to get some material may influence how you feel about it at the time and it is not always easy to be objective. This is detrimental to your work. I have therefore allowed myself on occasion to use Bill's photographs as the springboard for my ideas.

In Masset, we borrowed a car and photographed the village and its few remaining totem poles. In Skidegate, we did the same, mostly in the morning and in the evening during the hour before sunset. This time of day, called the golden hour, lends a warm glow to everything. The long shadows it produces help in compositional planning. The Spanish artist Sorolla painted only during the golden hour throughout his long life as a painter. As I work most of the day, I try to impose my own conditions on the scene I am painting.

I like to be able to feel wind, rain, sleet, impending rain, impending sun, growth, decay, struggle, or peace. 'Only connect,' E.M. Forster advised, two beautiful words that have been an important part of my painting life. For all the talk about the private sources of inspiration, an artist is in the business of communicating. Only when feelings felt strongly

40 BLACK-NECKED STILT, *lithograph, 5³/4 × 6 inches (image size)*

by the artist are successfully communicated to the viewer has the work fulfilled its purpose.

I have an ongoing love affair with graveyards. Wherever I go, I search them out. In Skidegate and in other places on the Charlottes there are marvelous cemeteries full of carved beavers, eagles, and totemic figures of the past, overgrown and unkempt. My imagination is stimulated, and it helps me become sensitive and aware of different aspects of my surroundings. 'Vita brevis est, ars longa,' said Seneca. Life is short, art is long. I guess that is one of the reasons figurative artists like to reinforce and renew the past by painting monuments to death like graveyards. Paintings, like tombstones, will last a good five hundred years, well into twenty or thirty generations. Pleasant hours are spent in lovingly producing works that are destined for frequent reframing, restorations, and reevaluations. The result of the painter's happy hours will be seen by human eyes countless times. Over the decades certain works may go in and out of fashion, be stuffed in attics and closets only to be pulled out at a later date. Critics are the products of their own times and biases and what they have to say about works of art is as transient and insubstantial as fashion. A painting has an intrinsic value which has nothing to do with critical assessments. I have always found it a testament to the importance of painting that the first thing many people do when their home is on fire is to grab their paintings and then run out.

Photographs are not yet held in the same kind of esteem, I think mainly because photography, being the most ubiquitous art, is something that most people feel they can do themselves. It doesn't seem specialized the way painting does. Perhaps the great photographs, those that will elevate photography to an art, have yet to be taken.

Back in Mexico in the winter for our annual rejuvenation, we visited Zihuatanejo, Acapulco, and Taxco for the first time.

In Cuernavaca, we checked into an absolutely marvelous old hotel called Las Mananitas. Surrounded by high walls, this charming garden paradise seemed to be an ideal place in which to work. There were several novelists with their busy typists staying while we were there. They sat in the gently sloping garden, interrupted by calling peacocks, strutting cranes, and waiters delivering tall glasses of lemonade. Every day dawned sunny and warm. Each creator sat in his own bailiwick, looking into his own space, involved with his own inner world. Around us in the garden, motionless statues encouraged us in our labours by reminding us of the permanence of artifacts. Good company and excellent food awaited at the restaurant there should we wish to avail ourselves of its services. This is a place that makes you feel like Malcolm Lowry or D.H. Lawrence, both of whom had been there. Passersby can see the evidence of what a painter is doing, unlike a writer whose work is only visible when he wants it to be. No one would have the courage to walk up to a writer and ask to look at the last few pages of his manuscript, but they feel perfectly comfortable staring over an artist's shoulder while he is trying to paint. Curious tourists would sometimes follow my progress through binoculars.

The following April, I went by car to Ucluelet, and to Tofino, small fishing villages on the west coast of Vancouver Island, and I painted in the area on Long Beach where Lismer had worked. I had chartered a light plane and flew to the Indian village of Ahousat. For a few dollars an hour, you can keep a plane waiting, and I walked into the village and located the place where Emily Carr had done a painting forty years earlier. The village had grown and been modernized but it gave me a great thrill to work on the same location. A small boy came and stood beside me, watching my progress on the panel. After a while, I noticed him below talking to the pilot

who was trying his best to hold the plane down in the gusty wind. Later, he came up beside me again and said, 'You see the pilot down there? He says you are crazy.' He then turned and walked away.

During my third trip to Gallup, New Mexico, I started doing lithographic drawings in a serious way. I took with me a bundle of paper masters on which I could do sketches or finished drawings with a grease pencil, a lithographic pencil or jiffy-marker ink. When I had finished my drawing and someone wanted a copy I would write their name and address just off the side on the master. When it was printed later, I could roll it up, put it into a mailing tube, and send it to the sitter. It is possible to put out a dozen or so prints in an evening in editions of about twenty to fifty each. The lithographic paper holds up very well to editions of one hundred or so, if you want to go that far. I generally stop the press earlier. Some time later, I would add watercolour to those drawings which deserved further enhancement.

In 1972, I purchased the smallest, quietest trail motorcycle I could find, a 98cc Honda which I carried on a rack on the back of the station wagon. The Honda had a large paint box permanently attached behind the seat. This, I felt, was an excellent way of getting into difficult areas with a minimum amount of trouble. But then I discovered that even the quietest motorcycles are unwelcome in Canada's national parks. Furthermore, while the motorcycle itself was very light, the total package became a little heavy to get over the occasional logs across pathways that you don't even notice when you are walking. Motorcycles, I also found, don't work well in the snow, and so I was limited to excursions below the snowline. When the road ran out in the Kootenay area that summer, I took the motorcycle as far as I could go into the alpine meadows. As I quietly passed dedicated hikers, I was greeted

with frowns. Machinery is not approved of or appreciated in these lofty, sacred places. They did not know what it was like to carry twenty-five pounds of painting materials around in addition to the regular gear. When I found something to paint, I would merely put down the kickstand, get off and start to work. After a couple of years of doing this from time to time, I had a nasty accident and decided that I would sacrifice both the mobility and the frowns for the sake of safety.

At this time I was also getting interested in cinematography and purchased some 16mm equipment. I like the concept of a permanent horizontal format and the fact that you can pan the camera slowly from one view to another with such ease. The movement within the frame itself was exciting, and I appreciated the *mise-en-scène* that is possible with motion pictures. Many of my movies are simple, plotless eye massage, but I think they help me understand and appreciate composition and picture development. After two years and several Bolexes, I was beginning to realize that in order to do really professional work, I was going to need help: sound people, editors, etc. Painting you can do yourself. In movies you need a quorum.

Working in that studio on Marine Drive became a bit of a battle by late 1974 because of the constant pitter patter of little feet above my head. I like to be near my family but not so near that they interfere with the creative marathons that I like to subject myself to. Besides the old studio was filling up—you had to do the heel and toe polka to get to the easel. I looked around and found another waterfront home near which a studio could be built.

The Studio

This home, at 12711 Beckett Road near Crescent Beach, British Columbia, is a large rambling house with ample room for

the development of children. We moved in on January 1, 1975, and I began, with the help of my assistant, to build a perfect studio a mere four feet from the house. In its initial stages, it was a large room, twenty-five by thirty-five with only one window facing north. The studio can be transformed instantly into a small theatre by a power-operated, sixteen-foot screen which comes down in front of the window, cutting off all light. With remote-control projectors operating in

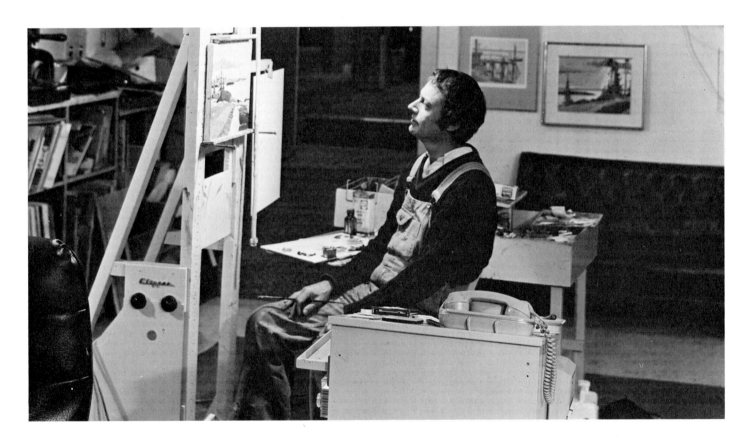

41 *In the studio, Crescent Beach*, 1980
photo: Bill Staley

the projection room behind, one can sit painting in semi-dimmed light referring to large panoramic landscapes. All you have to do is conjur up the chirping of the crickets and the tweeting of the birds to make it as good as the real thing. It is the closest thing to the exterior world that I have seen in an interior space. This studio is sound-proof, well insulated and heated with electricity, which I think is the best for an artist's

studio. In my previous studio I had a fireplace, which was good company and a ready facility for the elimination of offending paintings, but it left a residue of soot that fell on the surface of the paintings as they were drying. In my new studio I decided to create a dust-free, hermetically-sealed, modern work environment.

A good stereo system followed. I organize my daily routine in the studio around CBC FM. I love to paint by classical music and prefer not to have to put on tapes or records myself. While everything the CBC does is not conducive to good concentration, it is a small price to pay for the complete absence of advertisements. Certain music is terrifically inspirational and it is possible, months or even years afterwards, to look at a painting and remember the music that was playing during its execution. I believe that the music occupies the foreground of your mind and permits you to work from some other areas of the brain in a more automatic manner, perhaps tapping creative resources that would not be available to you in silence.

Spirited and lofty music inspires a confidence and gusto which manifests itself in the brushwork. Plaintive and flute-like music with extended melodic lines promotes delicacy and linearity. To a march I find myself putting down the heel of the brush in an aggressive rhythm. Music is the most abstract of the arts and it expresses the sound of the universe itself. These are the real rhythms that stimulate the artist's mind and guide his hand. There are times, of course, for complete silence. At these times I fill the void by talking to myself, just like the old man struggling to catch the fish to take home in Hemingway's *The Old Man and the Sea*.

One of the greatest advantages of having a separate studio is that the artist can have his materials set up and ready to go as soon as he walks in in the morning. Having to prepare a lot or spread out a kitchen table every morning is not the best way

to work. Artists should always try to have their own private place where interruptions and domestic distractions can be kept to a minimum. I have an intercom in the studio so that I can communicate with the house if I want to. Unfortunately, most of the communicating runs the other way: 'Daddy, can I have some more paper?' 'Daddy, my foot is bleeding.' Nevertheless it's great to have them nearby.

One of the most persistent interruptions that twentieth-century artists have to deal with is the telephone. It is hard to understand how people operated efficiently before the instrument arrived, but it can tyrannize an artist. Trains of thought jump the track when the telephone rings. Unfortunately, if you wish to remain a member of the human race you must own one, but there are two things that you can do to curtail its infringement on your privacy. The first is to acquire a telephone-answering machine. This device, when connected to the telephone and turned on, can give a message informing the caller that you are out of the studio or busy and that you will call back later. In the middle of large washes or some other project when it is crucial you not be disturbed, it is a good idea to have one of these things.

Another invention that is very useful for an artist who needs both his hands is the speaker phone. I have had one of these for fifteen years now. When the phone rings, you merely reach over and press a button. To the caller it sounds like you are speaking down a tin tunnel but it is possible to carry on a perfectly reasonable conversation from anywhere in the room without stopping what you are doing. Some people are offended by this device which gives it the added attraction of insidiously encouraging them not to call back.

In recent years, I have received several phone calls a day from artists, often beginning artists, who want advice or help which they feel they can get over the telephone. I have not discouraged this kind of thing and there are days when I really

appreciate hearing the sound of another human voice. While it is difficult to discuss a visual problem verbally without having it before your eyes, answers to such questions as 'What medium should I use?' or 'Which blue is best?' or 'How can I make sure my paintings are not dull?' can be dealt with quite satisfactorily over the speaker phone. When you wish to give full attention to some person or to some subject, you can switch off the speaker phone and speak on the instrument in regular fashion. Some people just want someone to listen to them, and you can go on with your work providing an occasional 'yes' or 'no' which seems to keep them happy.

The feeling of space and creative clutter that you get in a studio is a positive asset as far as I am concerned. I like to surround myself with my works, both recent and ancient, some good, some less so, some personal and some of a general nature. I know there seems to be a consensus among artists that previous paintings can spook you but I like to take that risk in order to determine the small things that may be needed to repair or improve them. I frequently go back and work for a short while on paintings that were theoretically completed ten years ago. I do not often recommend doing this. There is sometimes a tendency to overwork things. But often, if you force yourself to do remedial work you can save a potential failure from the rubbish heap. If a painting is really bothering you, the solution is just to turn it facing the wall for a couple of months. When it is around again, it may surprise you with its rightness and accomplishment. Hope springs eternal—maybe you can find something in an old painting that will redeem it and turn it into a worthwhile work. But there comes a time when you must gather together the hopeless failures and either remove them from the studio or put them to the torch. I build up to these ceremonial burnings two or three times a year, and when bonfire day arrives, I feel a catharsis is taking place. After it is over, I feel like a new man

treading new ground, 'born again' and ready to begin once more. Burning paintings may be one of the greatest feelings in art.

The Swell

We now began what my friends and I refer to as the 'Swell' years. In May of 1975, I took a part interest in an eighty-seven foot ocean-going tug with my friend Tom Stockdill. The Swell had a magnificent wooden hull with a displacement of 250 tons and was not modified in any way with the exception of the removal of the power winch. It was a steady, reliable vessel, safe in all conditions. Revenue Canada knew it as a 'floating studio.' I set up a device so that I could paint in my cabin and I mounted an easel on the fantail. Together with my tug-loving friends who helped to share the expense of running such a vessel, we poked into many of the tiny bays and inlets between Vancouver and Alaska during the next five years. Imagine the thrill of getting to places that were off limits to most travelers; lonely, isolated places where one could take in the environment in relative comfort, on your own terms, in your own time. The Swell itself was a lovely, private island that was completely self-sufficient. With a 5500-gallon fuel tank, it was possible, theoretically, to run from Vancouver to Japan. Tom, an airline pilot when he was working, was in complete control of navigating the vessel, and he taught me to operate the vast six-cylinder Enterprise diesel engine which lay below. I was eventually promoted to the position of Chief Engineer and could be relied upon to deliver, on call, any amount of power in any direction at any time. Many times as I sat painting in my cabin or on the fantail, I would hear the bells going, and have to run below and reduce power, stop engines, or go astern. There being no wheelhouse controls on this vessel, it required a team effort to operate it.

42 THE SWELL IN A
NORTHERN INLET 1975
oil on canvas, 16 × 20 inches

The first year, we circumnavigated Vancouver Island, taking several weeks to do so. We entered Barkley Sound on the third day, checking into a small bay on Effingham Inlet, and later Snug Basin further up the Sound. These sparkling islands, now part of the Pacific Rim Park, are different again in quality and design from the Gulf Islands with which I was familiar. I was later to learn that all the inlets up and down the

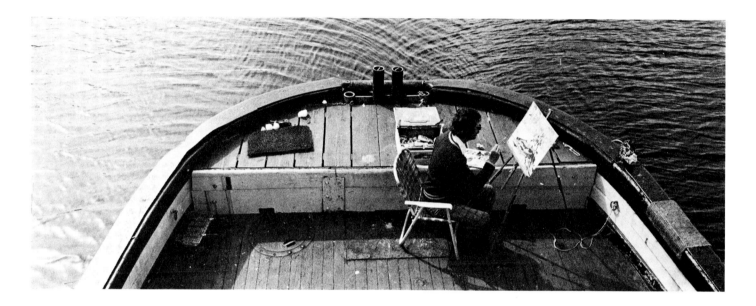

coast had beautiful, subtle differences—in the rocks, the shoreline, vegetation—that make each one distinctive. I was fascinated by these inlets. My friends used to kid me that I would write a book entitled 'Great Inlets I Have Known.'

At Hot Springs Cove, we sat in the lovely warm thermal pools and, towards the water's edge where the Pacific surges in and out, alternating between hot and cold, it is quite stimulating. In places like Winter Harbour, I rediscovered my love for the West Coast trawler and gillnetter, and the men who run them. At one point, we ran far out into the Pacific in black, forty-foot swells. The weather was poor and so we returned to the west coast of Vancouver Island and Tahsis Inlet, towards Friendly Cove on the same track that Captain

43 *Painting on the fantail of*
the Swell
photo: Reg Davis

James Cook had taken in 1778. What we saw as we neared the shore was practically identical to what Cook had seen, with the possible exception of a few logging operations which now marred the distant hillsides. We rounded the Brooks Peninsula past Solander Island, a bird sanctuary buzzing with puffins, on around Cape Scott at the northern tip of Vancouver Island and over the Nawitty Bar into Fort Rupert, an Indian village that I hadn't visited since my trip with the Howsons in 1962. My wet box was now full of oil sketches of the eight-by-ten and ten-by-twelve variety. There would be enough material for me to work on for some time.

Back on dry land, I did some work that summer in the vicinity of Westbank and Okanagan Mission near Kelowna. Later, in August, I flew to Great Slave Lake in the Northwest Territories, did some fishing with friends and proceeded on my own to Yellowknife and Tuktoyaktuk as the guest of Herbert Schwartz, the writer. Upon arriving at Tuk on the edge of Beaufort Sea, I was invited by an Eskimo whaler by the name of Kangkegana to go whaling the following day. With typical Greenpeace mentality, I asked him, 'Should we be killing whales?' He replied that every family in the village requires at least two whales per year in order to survive. Unlucky families are given them by more fortunate hunters. They use virtually every part of the mammal with the exception of the large intestine. These whales are of the small Beluga variety, and they migrate past Tuktoyaktuk every year in thousands.

In the summer in Tuk, the sun barely sets, and it is common to go visiting at three o'clock in the morning. In one friendly home, I was invited to try some fresh mucktuck that had been cured for a few days. I declined and they offered me something that they thought would be more to my liking. It appeared to be a plate of Kentucky Fried Chicken with two or

44 *Detail from lithograph of Esther Raymond*

three drumsticks, deep fried in batter. I began to consume one of these eagerly when I realized there was an eye looking up at me. The drumstick, as it turned out, was the head of a Canada goose, beak and all. I hated to turn down their hospitality, so I settled for a cup of tea which I found quite acceptable.

In Tuktoyaktuk there were a variety of interesting people working around their dwellings in the warm northern sun.

Smokehouse activities, the hanging of mucktuck, soapstone, whalebone and antler carving, and the curing of hides went on everywhere. It was like a living museum.

There was a beautiful Eskimo girl of about eighteen living there. When it was suggested that I paint her, she became very self-conscious and hid her face in her hands, only peeking out once in a while in the hope that I was looking somewhere else. This was going to be a challenge. She was practically impossible to talk to. After several attempts at conversation, on different levels, with little success, I asked her outright if she would pose for me. She answered with a very weak 'yes.'

45 THE VILLAGE OF TUKTOYAKTUK, *lithograph,* 6³/₄ × 17¹/₂ *inches*

I was not prepared for the scene that lay before me when I folded back the tent fly and entered her dwelling. She sat on a sleeping bag holding a baby in her arms which she was feeding from a can of condensed milk. Beside her sat a good-looking young man who was equally shy. In the middle of the floor was a cardboard box filled with groceries from the Hudson's Bay Store. A neat pile of well-worn comic books stood in one corner, and opposite a tiny stove crackled pleasantly.

I tried to make conversation as I produced my drawing pad and pens. All questions were answered quite cheerfully with short answers: 'yes, no, two months, boy, Silas,' etc. The young man held the baby, and the girl watched me shyly as I drew. Eventually, we all fell silent except for the baby who would occasionally gurgle away at the can held to his tiny mouth.

It was the girl who finally broke the silence. 'Why do you guys always come up here and want to do drawings of us, take our pictures, and use tape recorders on us?' I was completely unprepared for this question. This was so far the most I had heard her speak at one time. It was not an unfriendly question, just something that had been puzzling her.

'Well now,' I started. 'If you came to my part of Canada, you might be interested in coming to my home and seeing how my family and I live. It might be interesting to you.'

She became thoughtful for a minute and replied. 'Why would I want to do that when I have got all I want right here?' Since I could not come up with an intelligent reply I fell silent this time.

I did a lot of lithographic drawings in Tuktoyaktuk and, after I got back, produced a collection of these which I mailed back to Herbert Schwartz to give out to the people of the village. I think there were about thirty-six different drawings, and I sent two copies of each back. Apparently they were all snapped up, with the exception of two that were drawings of people who had moved away.

46 SILAS KANGKEGANA
Very good at catching whales
lithograph, 13 × 20 inches

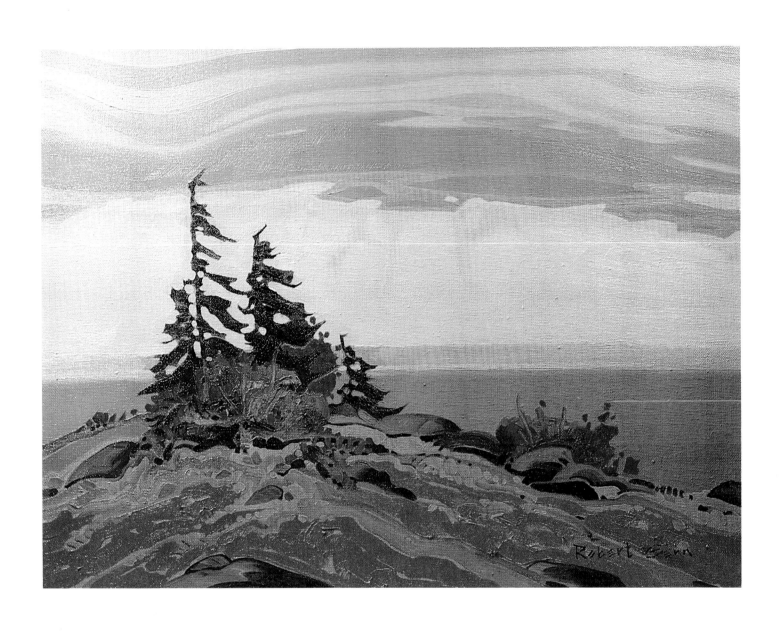

27 BLOWN GULF 1980
oil on board, 12 × 16 *inches*

In September, we took the whole family on the Swell to the area of Lasqueti and Texada Islands. At Lasqueti, a place where I like to paint, we anchored among a fleet of seiners and watched the fishermen as they set their nets out from the shore. The children swam joyfully from the boat and at midnight we would sit on the fantail, listening to Bach on the ship's sound system, and watching the Perseid showers that were particularly intense that year. What a feeling!

For our spring cruise, we decided on the inland passage to Prince Rupert. We visited Cape Mudge, Gowland Harbour, Fancy Cove, Mary Cove, Calvert Island, and Oona River. I did some work in all of these places. We took occasional days off in order to fish. It has always struck me that painting is somewhat like fishing. Some days there are fish, and some days there aren't. But if you keep your line in the water you usually get something eventually.

Back in the studio, I was still alternating between American Southwest, Mexican, and West Coast subject matter. I had good ideas flowing from the Tuktoyaktuk trip and, as a hobby, I was reverting to an activity that I had enjoyed very much in the past. This was the painting of people as ancestors of themselves. It is difficult. You have to get a likeness and achieve a semblance of aging the individual in such a way that he is still recognizable. I did this sort of work mostly for my friends. Nobody asked for these caricatures, I just did them. When I started getting requests for them, I lost interest in the project.

My attitude towards commissions in general has stayed more or less the same since I started. Fearing economic disaster I have always said yes to requests for portraits or paintings of people's children. What I have never said is when the portraits would be delivered. I still have an enormous file of portraits that are not yet begun, requests dating back as far as 1962. Every time I come across this file in my studio I feel

47 *David N. Ker as one of his illustrious ancestors. The nose has been shined up to emphasize a family characteristic. oil on canvas board*

terribly guilty. On occasion, I will pull out the reference, do one and surprise the person who commissioned it. But I feel I am not as good at commissions, especially portraits, as I am at just following my own inclinations on a day-to-day basis. I seem to have a reasonably good chance of completing an uncommissioned, unrequested portrait but I have trouble when there is someone that I have to please. Sometimes portrait-sitters cause problems, particularly children under four and women over thirty. They are by far the most difficult to paint.

In 1964, I was commissioned to paint four small children in one family. I did them in their home as they watched late-afternoon television with great absorption. Sibling one, two, and three all turned out well but I had a terrible time with number four. I just could not seem to get a satisfactory portrait done of him. Finally, I told the parents that I was going to give up for a while and try again later. The mother recently phoned and told me that he was getting married shortly and that he would like to have his portrait. I felt very badly about my failure but comforted myself with the knowledge that his grown-up portrait would look silly beside the baby paintings of his brother and sisters.

With regard to middle-aged women, it is the area that separates the amateurs from the professionals. I once painted a local celebrity who considered herself a bit of a sex goddess, and whose name shall remain anonymous. I delivered the painting to the dealer and, when she came in to pick it up, she took an immediate and intense dislike to the portrait and stormed out of the gallery. The dealer, a very resourceful fellow, dealt with her wrath by painting a small wart on the end of her nose and placing the large painting in the window of his gallery. He then telephoned the woman and told her that the wart would be enlarged a bit every day that she did not come in to pick up her masterpiece. She arrived at the

gallery soon after and completed the transaction within minutes.

Sooner or later in the production of commissioned portraits, a sense of disappointment overtakes me. The straightforward simplicity of arranging shapes and forms on a canvas, and the eternal variety of landscapes have always interested me more. They are a pleasure in themselves. I am compulsive about doing small panels, and I have wondered on occasion if I should see a psychiatrist over the matter. It is equivalent to the sort of doodling most people do while talking on the telephone. I find it an impossible habit to resist and, once given in to, difficult to stop.

On one occasion my compulsion was particularly evident. Jamie, my younger son, and I took a car trip to Mount Baker in Washington State. This entire area is laced with bumpy logging roads that have excellent foreground rocks, distant mist, and the occasional snowcapped peak in the offskip. In a particularly rough place, the gas tank of my stationwagon disconnected itself from the car and dragged along underneath creating a terrible fire hazard. There was nobody for miles, and we were in a very dangerous area. We got out, moved away from the car and sat contemplating our fate. Jamie was very unhappy about the situation but I spotted a terrific view just behind the car and felt I had to do something with it. Even with the chilling thought of having to spend a night marooned on a mountain looming in my mind, I was still able to produce a creditable eight-by-ten panel. Eventually, a couple of loggers showed up in a four-by-four and drove us back to civilization. I rousted two mechanics out of a saloon in a small town nearby, gave them a map and invited them to rescue our car. Jamie and I checked into a motel while they were gone and I did several more views from memory. Late at night, the mechanics returned with the car completely fixed

48 PORTRAIT OF CHARLES DIAMOND (*father of Helene*) *oil on canvas*, 16 × 12 *inches*

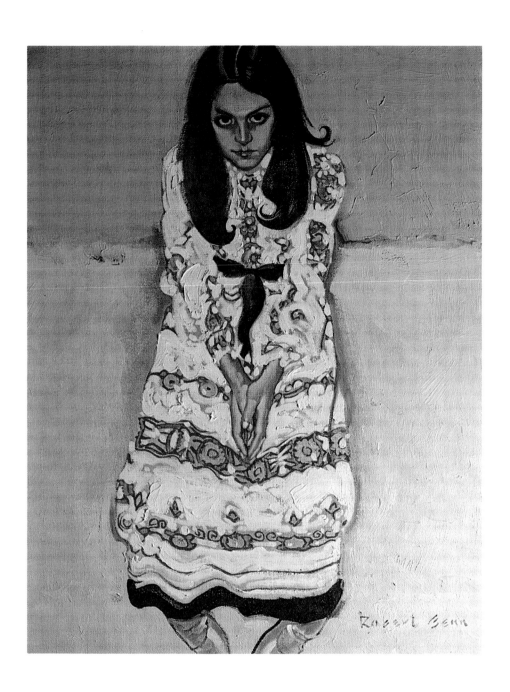

28 HELENE DIAMOND, AGE 13 1970
oil on canvas, 20 × 16 inches
Helene was a very nice subject, as were her brothers whom I also painted.

and charged me twenty dollars. I gave them both a painting in payment but I'm not sure they appreciated it that much.

In the spring the Swell headed north again, this time to the Queen Charlotte Islands. Leaving Calvert Island, we headed out across Hecate Straits in awful weather, using our radar and compass reckoning. We were not even five hundred yards off course when we arrived at the entrance of Skidegate Inlet. Anchoring near Tanu, Skedans, and Ninstints, the fabulous village on the southern tip of the Charlottes, we put boats down and went ashore. The only way to get to these places is by boat. In the Ninstints Harbour there is a collection of perhaps thirty-five totem poles still standing. Overwhelmed by trees and all weathered to varying degrees, they present a ghostly diorama of the past of the great Haida culture. Working in cedar, the West Coast Indians paid a heavy price in the decay of their work. Unless taken away and preserved the totems cannot last more than 150 years. Decay is everywhere. Man does not triumph over nature here.

At Rose Harbour, the nearby whaling station deserted in 1917, we sifted through the ruins, collected tiny antique opium bottles and filmed the oyster catchers and their nests. Giant stationary steam engines stood quietly by in the forest. The weather was alternately foggy and bright. During a bright period, I decided to take one of the boats to head back in the direction of Ninstints. I called my destination out to Tom and the time of my return. He called back, between the crashing waves, 'Don't do it!' I turned back. Within half an hour a terrible storm came up that would have kept me on Anthony Island for three days. Tom has an instinct for weather and has given me good advice on several occasions.

Returning from the Charlottes, I had enough material to keep me going for several months, but by August we were in Pine Top, Arizona, in the sparkling sunshine. I was back to drawing Indians at Fort Apache, on the Apache reservation

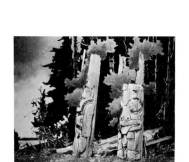

49 POLES AT NINSTINTS
1980
oil on canvas, 20 × 24 inches
Poles at Anthony Island on the
southern tip of the Queen
Charlotte Islands (Ninstints).
The forest overcomes the art.

nearby. The presence of large numbers of native people always thrills me. It is a great contrast to areas like the Charlottes where there are very few left.

By September, I was doing tamer subjects in the Canadian Gulf Islands. I was avoiding illustrative qualities in my work at the time and attempting to achieve what I considered to be the spirit of these places. The 'essence' was what I wanted to capture.

After spending a couple of months in the studio, I get anxious to go out and accumulate more material. The studio tends to oppress me after a while. Two or three weeks on location, and it again begins to seem like the ideal place to work. Sometimes I can hardly wait to get back. I love the efficiency of it.

During the summer and fall of 1977, we returned frequently to the Gulf Islands and stayed in various cabins. Nice people are always offering cabins to artists. David Ker, a Vancouver accountant who has been a friend of mine for many years, offered his frequently. Lenders of cabins generally expect artists to leave something behind to put on the walls. David had several paintings of mine from a much earlier time. Every time I went back to that cabin, I liked those paintings less. David didn't like them much either but I think they were the best paintings that I did during that particular spell in his cabin. One winter there was a break-in and the thieves took everything, right down to the knives, forks, spoons, and refrigerator. In fact they took everything *except* my paintings! They must have been classy thieves.

In May and June, we took an extensive cruise to Alaska on the Swell. Many artists wear beards, and so I have always shaved every day. I didn't want to be caught in 'uniform.' But for a few days on the way to Alaska, I simply forgot about the daily task. Pat, Tom's wife, remarked that I looked all right with a

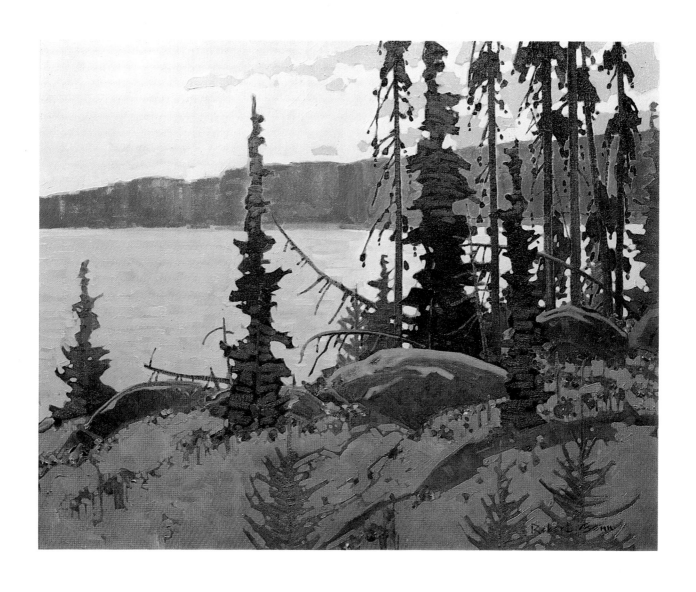

29 PATTERN PASSAGE 1980
oil on canvas, 24 × 30 inches

beard, especially with my admiral's hat on – very nautical – so I just let it go. I didn't shave for three years.

There was quite a bit of talk around our home as to what might be growing in that big, black beard. By October it had achieved a certain amount of fame. One evening a friend of mine asked me if I would shave it off for $10,000 and I replied that I would consider it. The following morning he phoned the studio to say that ten of my wealthier friends had gotten together and pledged to donate $10,000 to the Terry Fox Cancer Fund if I would submit to a shearing. I caved in in honour of the courageous one-legged runner that the whole world admired.

The fateful day arrived and the ritual sacrifice took place on the boat. Everyone, except me, had a wonderful time that day. They roped me to a chair and Ray Hennessey, a famous hair stylist, removed my beard in excruciating stages during two inebriated hours. I was feeling no pain myself and the cuts healed after a week or so. Jamie and Sarah gathered the beard into a nice bottle, and we auctioned it off to one of the more fortunate guests. The bidding was quite lively, and the beard ended up raising over $15,000. It is amazing how charitable your friends can be when you allow them an outlet for their sadism.

Around this time I did some good work around Ketchikan, Skagway, Glacier Bay, and Baranoff. We visited a place called Ford's Terror which was like the Grand Canyon with ice, viewed from the bottom. Tiny, glacial rivulets of azure water cascaded thousands of feet to the bottom of the fjord. The cliffs were so precipitous that even at mid-day the place was in shadow. A few good paintings were inspired by this place.

The Swell, anchored near Ford's Terror, had run into some difficulty. Our vital lifeline, the refrigerator, had broken down. We tried in vain to repair it as we watched our steaks

turning dark and a month's supply of food begin to deteriorate. We determined that we had leaking freon, and it became necessary to go to a large centre for repairs. This was difficult since we were two weeks away from Prince Rupert. We were about to give up when the penny dropped. Here we were in Alaska, with thousands of tons of broken glaciers passing us every day. We started the ship's largest winch and hoisted a modest glacier aboard. This lump served as an ideal freezer-refrigerator for two weeks. Like a beautiful display in a hotel dining room, it lay on the fantail doing its job. The sight of our fifteen-year-old French wines nestled on one-thousand-year-old ice was very appealing.

We were joined on this trip, as on several others, by Jack Hambleton, a western Canadian watercolourist. Jack has a good sense of humour and likes working outdoors. We enjoy each other's company and stimulate each other in a competitive sort of way. He does fresh, effective watercolours on location using a large brush. At one point, when the Swell was anchored in a particularly beautiful place, and everybody else from the boat had gone exploring, Jack and I decided to spend one full day on the boat doing nothing but painting. The boat swung around with the tide, disclosing different views every few hours. It is amazing what you can glean from one position if you concentrate. The wind was forever changing the quality of the ripples and designs on the water which gave interesting eye lead-in and compositional variety. Between the artists a long period of silence would be broken only by happy singing.

We stopped for lunch, had a short snooze, and proceeded to work all afternoon. Later that day, the others returned, and we joined them for dinner. Afterwards, Jack and I continued on the fantail until the last glimmer of light died about midnight. I had produced eight small relatively finished paintings. Jack

had done twelve. This kind of wholesale activity often surprises some people. Often when you are working on a series, numbers one and two are only fair, number three can be excellent, numbers four and five drop noticeably in quality, and seven and up tend to be good again. Unfortunately, in order to get to number three, you have to do numbers one and two and so on. It is an arc beginning slowly, rising to a peak and then declining again. As a generalization, it is possible to say that a seldom-painter is often a poor painter. He never gets past number one. Of course, it is possible to go too far the other way, producing too much and doing flashy, unthought-out paintings. Most of the artists whom I admire, Singer Sargent, Velasquez, Sorolla, Nicolai Fechin, all worked very quickly.

Back in the studio by August, I hired a new assistant. There are many tasks around the studio which can be handled by an assistant. Looking after the business side of being an artist is best given to an assistant, as is the stretching of canvas and the preparation and priming of panels. The small panels are most frequently one-eighth-inch mahogany, cut to the proper size. I don't trust products like Masonite anymore because some have acids lurking in them that darken the paint over the years.

After cutting the mahogany to size, it is primed, back, front, and edges with a mixture of Weldbond glue and water which is put on with a paint roller. This seals the panel, prevents its buckling, and keeps the paint from sinking in. After the sizing is dry, it is lightly sanded along the grain of the wood. I like the tooth of the wood which permits nice scumbling effects. The grain can be either vertical or horizontal. I allow the colour of the wood to show through or tint it with a light cloth rubbing of imprimatura based on linseed oil and a toning colour, frequently transparent grey or blue or a reddish tint. This imprimatura can be used to tone down and integrate

the later application of strong colour. There is a danger of using too much toning imprimatura which can drain the colour out of everything. Umbers and siennas should be generally avoided in this matter. I practically always work *alla prima* – wet into wet.

Having help in the studio leaves your mind free to roam. You can concentrate on those things that you do best. Some artists find it difficult to work with another presence in the studio but I have found it does not bother me unless the relationship becomes too social. One day, as I was painting, I became aware that my assistant was picking remnants of paint rags out of the casters of the chair on which I was sitting. That was a bit too close.

In the fall, the American Gulf Islands looked interesting. I had not explored them thoroughly before, and so we headed off in the Swell for San Juan Island, Friday Harbour, and Roche Harbour. Later that month, Carol and I flew to another island, this time the Isle of Man, in the Irish Sea between England and Ireland. The Wallises had now moved to Laxey on the Isle of Man. Bert had a pile of books about one foot high lying beside my bed when I arrived. After fifteen hours of air travel and two hours of hassle at Heathrow, he expected me to read up and become completely knowledgeable on what I was about to see. Bert was bubbling with enthusiasm for the views around Peel, Castletown, and Lonan. It took us several days to assimilate this land of fairies and the Manx cat. Sparkling seaside villages such as Peel were safe harbour for fishermen and lobstermen. A feeling of insularity and national pride is characteristic of the Manx. The Island has vast stretches of lonely heathland and fortress-like groupings of houses.

Aloofness, privacy, and independence are some of the things I value in islands. On the west coast of British Columbia, I have been on hundreds of islands. Accessible on our

50 QUEEN'S COVE CHURCH, *lithograph*, 5 × 6 *inches*

·120·

Swell cruises, they were populated with blue camass, shooting stars, chocolate lilies, and yellow monkey-face flowers. They were ruled by the bald eagles. Here on Man, there was a developed and mature civilization with over one thousand years of internal peace. Perhaps the fascination has something to do with the fact that functioning in lonely insularity, battered by the four winds and the tides of fortune, we construct our defence by knowing our boundaries. The ultimate boundary on land is the mysterious sea. One of these days, I am going to paint a picture that expresses this feeling.

The following year we again traveled the west coast of Vancouver Island, paying particular attention in the first week to the Bamfield and Grappler Inlet area. Here again, near the western terminus of the Pacific Cable, houses, boathouses, and floats struggle against the tide, the wind, and the weather. The life-boat station with its red-painted unsinkables waits to do its duty in the rough Pacific around the corner.

People are few and far between from there, north on the west coast. Indian villages such as Queen's Cove and Friendly Cove with its picturesque lighthouse station, invite visits. In the Broken Group, we anchored near the floating cabin of Salal Joe, a bearded recluse who had been a resident there for forty years, living off the land and earning a small amount of money by gathering salal and shipping it to Vancouver for inclusion in floral decorations.

Paintings, once completed, disappear onto someone's wall. This presents a problem for the artist; paintings are often difficult to relocate for reevaluation. There are certain pieces I would like to find and look at again. It would be an enlightening, instructive and perhaps humbling experience to see the poorer ones once more. The natural impulse with the less successful works is to want to buy them so that they can be destroyed. I would have to be a multi-millionaire to do this with any degree of efficiency. When good ones are

51 SALAL JOE 1979
oil on canvas, 24 × 30 inches
An example of an oil painting which has been toned down by glazing and with some areas wiped out later.

rediscovered it is like meeting a much-loved old friend again. Fortunately for artists, beauty is in the eye of the beholder, and tastes in art are very personal.

I had previously been involved in lithographic drawing and commercial prints. At this time I was beginning to take serigraphy seriously. Serigraphy, or silk screening, involves close cooperation between the printer and the artist and it is possible to achieve many unique effects. I felt my work with its two-dimensionality and pattern qualities would lend itself quite readily to this process. Since my teens I had been in love with the wood-block printing of W.J. Phillips, whose technique and design style have greatly influenced my own work. Phillips, a fussy and exacting worker, maintained excellent quality control over editions of up to 250, some of which had fifteen colours, and each a separately carved wood block. His craftsmanship was second to none in Canada, and I knew from the very first day that I saw his work that they would be collectible at some time. The market results of Phillips' work have borne me out.

Wood-block work was new to me but I had had considerable experience doing silk screening in my father's sign shop and understood the process of both photographic and hand-cut techniques. At the time my idea was to produce prints of four to eight of my better images each year in a modest edition of perhaps eight to one hundred. After a few still-born attempts I seemed to codify my ideas as to how these works should look. Prints that seemed to turn out well were 'Islets,' 'Gulf,' 'Village,' 'November' and 'Coppice.' New pitfalls were constantly being discovered with each new print but they improved as I went along.

I love the frustration of doing this kind of work. It is more difficult to visualize the final result than it is with an easel painting which can often be done in one sitting. Serigraphs can take three or four weeks, each colour being a separate run,

and they go through several stages of development.

In January 1980, I visited a Canadian artist friend by the name of Nahu who lives near Puerta Vallarta in Mexico. Nahu markets his work himself from a beautiful palm-covered collection of shacks, called Pueblo Pacifico, on a hillside overlooking the blue Pacific. He is, however, always wondering where his next peso is coming from, and this reinforces two things which I believe are vital to the happiness of a painter: one is talent, which he has, and the second is someone, besides yourself who also feels that your work is worth something, and this he has not.

Dealers are a necessary evil in art transactions. They do, however, provide a buffer zone between the ego of the artist and the public, and they make it possible for artists to create independent of popular opinion. Artists with serious aspirations need to be left alone to follow the course of their own imagination. They do not need the applause or condemnation of the critics, the ideas of other artists, or the demands of the collectors. Successful artists exist pretty much in their own world, and they like to keep it that way. Painting is not a committee job. Just as the student, who observes what his classmates are doing, finishes the semester having learned nothing, so an artist must learn to trust in his own personal vision and judgment. The thing that keeps artists going is the feeling that what they do is exclusively theirs and no one else's. There are 360 degrees on the compass. A course must be struck and faithfully followed.

In March, Carol and I took our three children to Holland, Belgium, Luxembourg, France and England for an educational tour. We insisted that they keep daily diaries and take their own photographs of places they found interesting. Jamie, who is a cat lover, had his picture taken with his head in the mouths of the lions of Trafalgar Square, the leopards of Brussels' pavilions, and any other place he was able to find a feline.

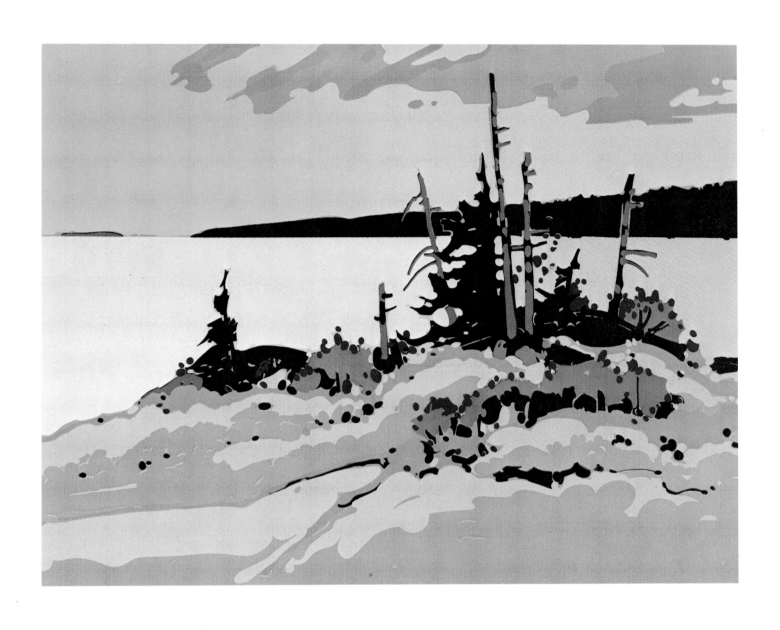

30 COPPICE 1981
serigraph, 12 × 16 *inches*

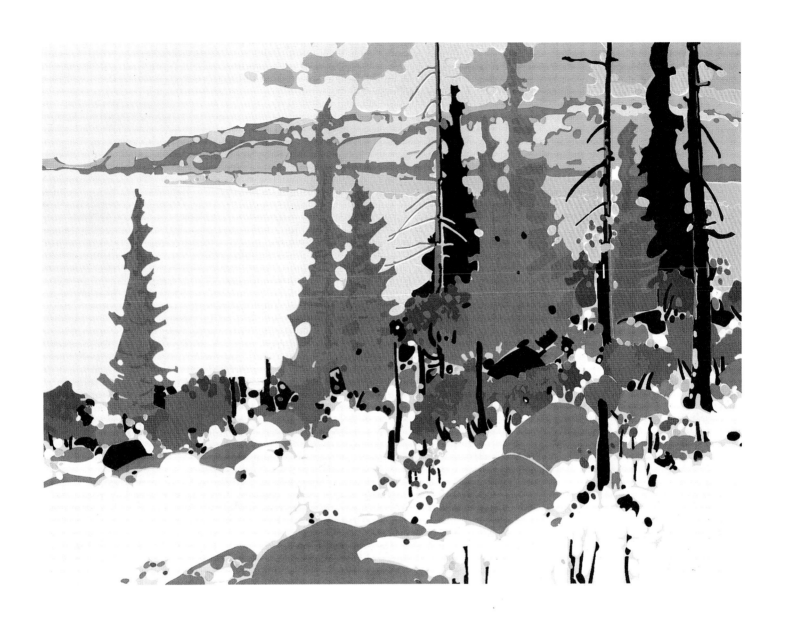

31 GULF 1981
serigraph, 12 × 16 *inches*

When the family left in April, I stayed on in England with Ted Taite, a neighbour from Crescent Beach. I had purchased, over the phone, a 1937 Austin 7 in Minehead, Somerset, and Ted and I went down, picked it up and drove it from Land's End to John O'Groats. With this tiny, perfect, beautifully restored car, we made our way through Cornwall, Devon, and up the centre of England to Scotland at an average speed of nineteen miles an hour, all of it on secondary roads. I have always believed that the most fortunate man is the man who walks, and driving a slow vehicle like the Austin is second best. I had some equipment to bring with me, and it would have been difficult walking with all that stuff. We got to know the rabbits and the hedgehogs on a first-name basis. It was a great opportunity to ingest the beauty of the British country-side. Ted, who is keen on good food, had an excellent restaurant selected from his traveling gourmet library by five o'clock every afternoon. We dined well and stayed in lovely, remote, picturesque places every night. There are thousands of places in England where a person could drop out of sight and spend the rest of his life painting.

Back in Canada, we were getting pressured to sell the Swell. A man who had been after Tom and me for several months finally made an offer that was too good to refuse. He wanted to put the tug back into service as a towboat, and this appealed to both of us. We decided to put our money into a term deposit and forget about boats altogether for at least a year.

The Fifer

A couple of weeks went by, and we were both longing to be up the west coast again. Tom showed up at the studio one day and informed me that a well-known, classic yacht, the Fifer, was for sale. This magnificent Vancouver-built, steel-

hulled, 105-foot vessel, had every comfort and amenity available to the yachtsman. It was an outrageous luxury but we made an offer. I gave Tom my power of attorney, as I was often out of town at that time, thinking that nothing more would come of it. I returned to the studio one day as the phone was ringing. I picked it up and heard Tom say, 'Would you like to come and have a look at our boat?'

Within a month, we were all back in Desolation Sound in our new beauty. We chartered the boat in the summer in order to help pay off our sizeable mortgage. The Fifer has a matched set of speed tenders which offer considerably more range than what we had on the Swell. The Fifer was built to go around the world and perhaps one day we will do just that, looking for more islands in the sun.

By August, the Fifer was booked up with summer charters, and Tom was wondering why he had gotten into the floating hotel business. I was off with my twins on a camping trip by car to Tatlayoko Lake in the Chilcotin. It is a great experience to travel with eight-year-olds. We ate from cans and stayed up late, mainly trying to stop the leaking in the tent. I did several large oils on the edge of Wilderness Lake. Sarah and Jamie were off every day horseback riding, and they loved it. On the last day, I did a twenty-five mile ride to the magnificent alpine meadows, the snowline, and the home of ptarmigans.

Later in the month, Bill Staley and I took off for Gallup, New Mexico, my fifth trip to the Inter-Tribal Ceremonials. It was great to see it through Bill's eyes, although I knew pretty much what to expect having traveled with him before. Bill's photographs from that trip were superb.

Photography and its off-spring, cinematography, are currently the most vital of the visual arts, and their possibilities have only begun to be explored. The best picture-thing in the world, in my opinion, is the *National Geographic* magazine. Henry Ford is reputed to have said to an art dealer, 'Why

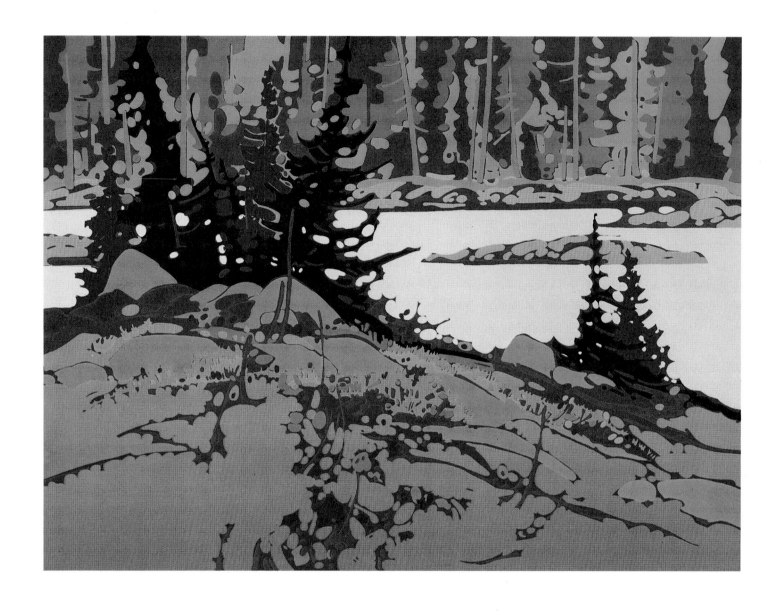

32 ISLETS 1981
serigraph, 12 × 16 inches

would I want to buy paintings when I have all those lovely pictures in these magazines right here?' The video tube itself brings millions of images of foreign places, strange, beautiful, wonderful things directly into our homes everyday. Pictures of all varieties freeze reality and permit us to examine it at leisure. Photography is on the way in. It has driven painters, during the past one hundred years, to reevaluate their own activity against this new-found, mechanical means of visual expression.

There is no question that art has profited from the challenge of photography. Of late, various figurative and abstract artists have come to rely on the camera as an accepted tool for the development of visual ideas. I started taking photographs seriously when I was about fourteen with a postcard-size folding Carbine camera with six black-and-whites to a roll. By the time I had finished high school, I had moved up to a 35mm camera transparency format. At present I have sixty-thousand slides in a catalogued archive.

Photography has been one of the most enduring of my interests over the past twenty years. It is a beneficial activity for artists, heightening powers of observation and developing sensitivity. The photographer has the advantage of being able to see the world in a frame, that is through the viewfinder. Normal vision is soft on the periphery and inadequate for the pictorial needs of a painter. About 1960, I discovered what I call the rule of 360. When you are moving through a landscape and something attracts your attention, photograph it, and then slowly rotate looking through the viewfinder of the camera, 360 degrees. A better and more interesting composition will invariably come into view. This augments the richness and depth of your perspective.

Photography, improperly used, is a terrible master. But if understood and kept under control, it is a useful servant. The artist of today with the aid of the camera, has the ability to

inject more imagery and more visual variety into his art than the painters of the Renaissance could dream of.

In November, I flew with my father to Pernambuco and Olinda in Brazil, the Argentine, Chile and Peru. No artist could possibly assimilate and remember the costumes, people and archaeological sites without the help of the camera. The camera, however, will never replace the activity of applying paint to a canvas or panel. Easel painting, with all of its problems will provide a challenge to mankind for a long time yet. It is like hunting in a forest for an elusive fox. It is also one way of using the environment without taking anything directly from it.

Robert Frost was once asked why he preferred to continue working in tight-metered and rhyming lines when more modern poets were turning to free verse and relatively undisciplined writing. Frost remarked that he 'played better tennis because the court was there.'

For the painter the panel is the iambic pentameter and the rhyme scheme; it is the structure within which great things can be created. I have done a few good paintings so far, but the best, I hope, are yet to come. In any case, it has been a good trip.

CHRONOLOGY

1936
May 15 / Born in Victoria, B.C.
Father Hugh Douglas Genn, Mother
 Florence Genn (Caton)

1938
Living in Cordova Bay, near Victoria.

1940
Move to 3942 Cedar Hill Cross Road,
 Victoria.

1941
October 30 / Brother Denis M. Genn born.
Father starts business for himself.
Advertising and sign work.
Attend Mrs Patterson's kindergarten.

1942
Attend Cedar Hill School. Draw airplanes,
 battleships, cars.

1945
Attend Cloverdale School.
Saturday morning art classes with
 John Lidstone.

1947
Take watercolour lessons with Will Menelaws.

1948
Travel to Mount Ranier with parents.
Take first photographs (Brownie Hawkeye).

1949
Attend Doncaster School.
Move to 3915 Persimmon Drive, Victoria.

1950
Attend Mt Douglas High School.
Work on school annual. Work for father in
 sign shop, silk screening, spray painting.

1951
Active bird watching. Birds (*p*) fungi (*p*).
Day trips to Sooke, Goldstream (*p*).
 Mt Douglas Park(*p*). Painting in water-
 colour. Lost Lake (*p*). Parksville (*p*),
 Comox (*p*) in oil.

1952
Acquire first car. 1929 Hupmobile Coupe.
Travel to Okanagan Valley with Fen Lansdowne.

1953
June / Graduate from Mt Douglas High School.
July / Travel by car to California, Nevada.
Attend Victoria College. Arts and Science.
December / Trip to Athens, Ohio.
Edson, Alberta (*p*). Winnipeg, Manitoba (*p*).
Ohio in winter (*p*).

1955
June to August / Work as fish-pitcher and
 store boy at Beaver Cannery in Rivers Inlet.
Also as cook/deckhand on small fish packer.
 Klemtu, B.C. (*p*), Rivers Inlet (*p*), Beaver
 Cannery (*p*).
September / Back in Victoria. Take the year
 out from university.
Collect subscriptions for local newspaper
 the *Saanich Star*.

1956
Attend second year Victoria College.

1957
Attend University of British Columbia,
 Vancouver. Live on Balsam Street, Kerrisdale.
August / Attend U.B.C. summer school.
September / Attend Art Center School, Los
 Angeles, California. Industrial Design.
 Live at 98 S. Magnolia, Los Angeles.
Exhibit locally. Live at Beverly-Sycamore
 Apartments, Hollywood.

1959
Leave Art Center School returning to Victoria.

1960
Oil painting self-education.
August / Live with Mrs E.H.B. Giraud,
 1050 Blanca, Vancouver. Paint in garden (*p*).
September / Set up small studio at 1155
 W. Pender, Vancouver.
Live with Mrs E. Wood, 4334 W. 3rd.,
 Vancouver. Paint in garden (*p*).

1961
Attend Vancouver Public Library frequently.
Paint in Pender St. studio. Do occasional
 advertising drawings.
Establish first relationship with Vancouver
 dealer, The Art Emporium.
April / By car to Okanagan (*p*).
September / By car to Cariboo (*p*), Gulf
 Islands (*p*).

1962
Work with A.M. Bell and Associates,
 Vancouver. Freelance art for advertising.
April / By boat to Kwakiutl area: Alert Bay
 (*p*), Kingcome Inlet (*p*), Fort Rupert (*p*)
 with Harry and Tim Howson, purchasers
 of Indian art.
July / Meet Carol Shimozawa.

1963
February / By amphibian to Savary Island (*p*).
 Small watercolours produced.
April / Savary Island (*p*) with Don Wilson.
August / By car to Cariboo lakes (*p*).

1964
Small 8 × 10 and 10 × 12 oil on panels.
August 29 / Marry Carol.
September / Travel around Europe in VW
 bus to Holland (*p*), Germany, Bavaria,
 Ulm (*p*), Augsburg (*p*), Munich (*p*),
 Austria (*p*), Italy (*p*), Yugoslavia (*p*),
 Greece (*p*), Naples, Capri (*p*), and
 France (*p*).
November / Live at 'Alta Luna' near Castle
 Sohail, Fuengirola, Spain.

1965
Paintings at Fuengirola (*pp*), Mijas (*p*),
 Nerha (*p*), Rhonda (*p*), Marbella (*p*),
 Gibraltar (*p*), Ceuta (*p*).
August / Bradbourne, Derbyshire (*p*).
 Guests of C.H. Wallis.
October / Copenhagen, Denmark (*p*).
 Speroi, Norway (*pp*) on Christianafjord.

NOTE: (*p*) after a place name denotes one or more paintings exist. (*pp*) after a place name denotes many paintings exist.

December / Sail from Bristol, England to Halifax, N.S. by freighter.
Halifax (p), Algonquin Park, Ontario (p). Cross Canada by car (VW) in winter (p).

1966
January / Move to 96 W. 18th, Vancouver, B.C.
April / By car to Quilchena, B.C. (p), Nicola (p), Merritt (p).
Work part-time as personnel manager for investment firm.
September / By car to Skeena valley: Kispiox (p), K'San (p), Kitwanga (p), Kitwancool (p), Prince Rupert (p).
October / Montreal (p).

1967
January / Puerta Vallarta, Mexico (p).
April / Move to 13674 Marine Dr., White Rock, B.C. (p).
Crescent Beach (p), Elgin (p), Hazelmere (p).
August / Drive to Cariboo (p), Chilcotin (p).
October / Japan: Tokyo, Kobe (p), Kiushu (p), Oshima Island (p), Odawara (p), Nishioi (p).
November to December / Paintings of Japan.

1968
January / By car to Toronto via Sudbury (p), Wolcott, N.Y. (p), Pittsfield, Mass. (p), Upstate, N.Y. (p). Visit Norman Rockwell (Stockbridge, Mass.).
August / Canadian Gulf Islands by car: Mayne (p), Saturna (p), Galiano (p), Saltspring (p).

1969
January / Puerta Vallarta, Mazatlan (p), Mexico.
March 2 / David Robert Madison Genn born (p).
May / Acrylic paintings.
July / By car to Winnipeg, Man. (p), Yorkton, Sask. (p), Morse, Sask. (p).
August / Bradbourne, Derbyshire, U.K. by car to Eire: Connemara (p), Dingle (p). By car to Cambridge, U.K. (p).
Buy 1937 Bentley in Leek, Staffordshire (p).

1970
January / By car to Virginia City, Nev. (p), Taos, N.M. (p), Acoma, N.M. (p), various pueblos (p), Hopi, Navajo (p).
April / Bentley delivered to Vancouver.
Southwest, west coast people in environment (pp).
August / First trip to Gallup, N.M. Inter-Tribal Indian Ceremonials (p).

1971
January / Mexico: Mexico City, Yucatan (p), Isla Mujeres (p), Oaxaca (p).
February / By car to western Alberta, Banff (p), Canmore (p), Usk (p).

May / By car to Skeena valley, Morristown (p), Hazelton (p), Usk (p).
August / Second trip to Gallup, N.M. (p).
By car to Quilchena, Banff, Revelstoke (p), Golden (p).
September / Saltspring Island (p).
October / La Connor, Wash. (p).

1972
February / Kleinburg, Ont.
May 27 / Twins James Douglas Hawke Genn and Sarah Jennifer Genn born (p).
Observe local ballet school, children's dance classes (pp).
September / By car to Lillooet (p).

1973
Landscapes from reference, imagination.
April / By car to Cape Flattery, Wash. (p), Neah Bay (p).
August / Queen Charlotte Islands with Bill Staley, photographer.
Masset (p), Skidegate (p), Tlell (p).
September / By car to Whistler (p), Alta Lake (p), Pemberton (p), Lillooet (p), Bralorne (p).
November / Montreal, N. Hatley (p).

1974
January / Mexico: Mexico City, Cuernavaca (p). Taxco (p), Acapulco, Zihuatanejo (p).
April / By car to Tofino, Long Beach (p), Ucluelet (p), Ahousat (p).
August / Third trip to Gallup, N.M. Lithographic drawings with Clint Davies.
September / Kootenay, Kokanee (p), Nakusp (p).

1975
January / Move to 12711 Beckett Rd. near Crescent Beach, B.C.
Build separate studio beside home.
February / Interest in cinematography begins.
May / Spring cruise around Vancouver Island on Swell with Tom Stockdill.
Barkley Sound (p), Sung Basin (p), Effingham Inlet (p), Hot Springs Cove (p), Winter Harbour (p).
June / Kelowna, B.C. (p), Westbank (p), Okanagan, Mission (p).
August / Great Slave Lake, N.W.T. (p), Yellowknife (p), Tuktoyaktuk (p). Lithographic drawings.
September / Lasqueti Island on Swell.

1976
May / Spring cruise inland passage to Prince Rupert on Swell. Gowland Harbour (p), Fancy Cove (p), Mary Cove (p), Calvert Island (p), Porcher Island, Oona River (p).
September / Gulf Islands on Swell (p).

1977
April / By car to Mt Baker, Wash. (p)
May / Spring cruise to Queen Charlotte

Islands on Swell. Skidegate (p), Skedans (p), Tanu (p), Ninstints (p).
August / Stuart Island (p).
Pine Top, Ariz. (p), Fort Apache (p), Phoenix.
September, October / Frequent trips to Canadian Gulf Islands.

1978
April / Kalispel (p), Montana, Idaho, and Washington State (p).
May, June / Spring cruise to Alaska on Swell. Ketchikan (p), Skagway (p), Glacier Bay (p), Ford's Terror (p), Baranoff (p).
August / Assistant Jayne Mason starts.
September / Cruise of American Gulf Islands on Swell. Roche Harbour (p), Friday Harbour (p).
December / By car California coast (p), San Francisco, Berkley, Oregon coast (p).

1979
February / Isle of Man: Laxley (p), Peel (p), Castletown (p), Lonan (p).
England: Cambridge, London.
May / Spring cruise around Vancouver Island on Swell. Klaskish (p), Broken Group (p), Pacific Rim Park (p), Banfield (p), Grappler Inlet (p), Friendly Cove (p).
August / Stuart Island (p).
September / Serious serigraphy begins.
October / By car to Lloydminster, Sask.

1980
January / Puerta Vallarta, Mexico (p).
March / With family in Holland, Belgium, Luxembourg, France, and England.
April / Land's End to John O'Groats by Austin '7'. Cornwall (p), Devon (p), Lock Tummel (p), Scotland, Loch Ness (p).
May / Assistant Ulrike McLelan starts.
Spring cruise on Fifer to Desolation Sound (p), Prideaux Haven (p), Hardy Island (p).
August / By car to Chilcotin. Wilderness Lake (p), Tatlayoko Lake (p).
Fourth trip to Gallup, N.M. with Bill Staley, photographer. Taos (p), Acoma (p), Santa Fe (p).
November / Pernambuco, Olinda (p), Rio (Brazil), the Argentine, Chile, Lima Cuzco (p), Macchu Piccu (Peru) with father.

1981
January / Po'ipu, Kaua'i (Hawaii). Writes *In Praise of Painting*.

LIST OF ILLUSTRATIONS

All works of art included in this publication are from private collections.

DESIGN

The Dragon's Eye Press

PRODUCTION

Paula Chabanais Productions

TYPESETTING

Trigraph

FILM

M.P. Graphic Consultants Ltd

LITHOGRAPHY

Ashton Potter Limited

BINDING

The Hunter Rose Company Limited

PAPER

100 lb Warren's Patina Matte

TYPEFACE

Bembo